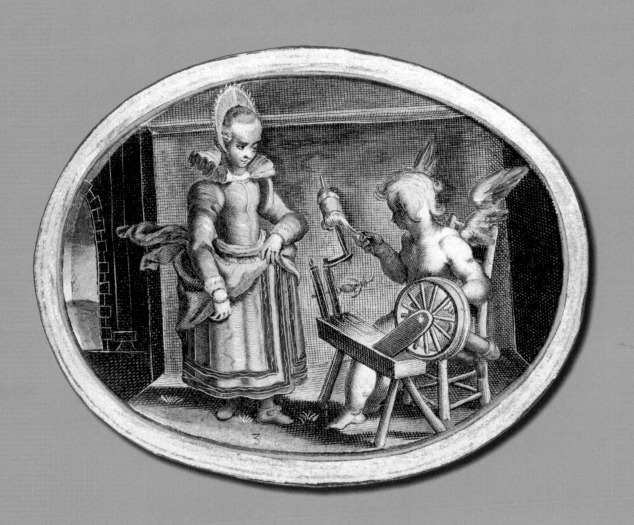

3

WINGS

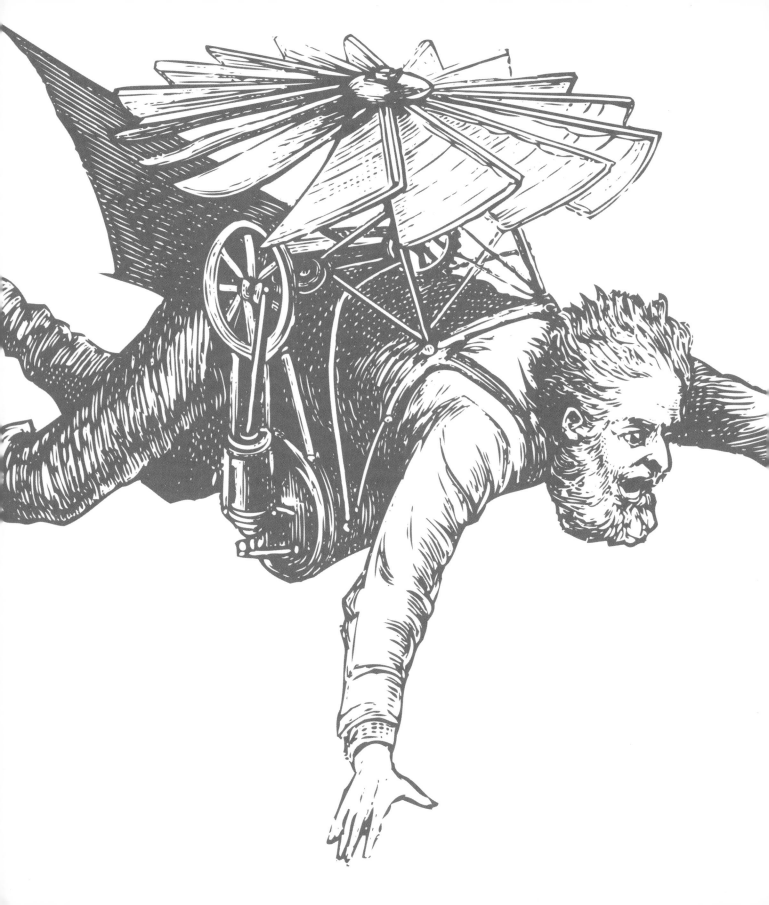

WINGS

DOVERPICTURA

DOVER PUBLICATIONS, INC. | Mineola, New York

Planet Friendly Publishing
✔ Made in the United States
✔ Printed on Recycled Paper
 Text: 10% Cover: 10%
 Learn more: www.greenedition.org

GREEN EDITION

At Dover Publications we're committed to producing books in an earth-friendly manner and to helping our customers make greener choices.

Manufacturing books in the United States ensures compliance with strict environmental laws and eliminates the need for international freight shipping, a major contributor to global air pollution.

And printing on recycled paper helps minimize our consumption of trees, water and fossil fuels. The text of *Wings* was printed on paper made with 10% post-consumer waste, and the cover was printed on paper made with 10% post-consumer waste. According to Environmental Defense's Paper Calculator, by using this innovative paper instead of conventional papers, we achieved the following environmental benefits:

> **Trees Saved: 10 • Air Emissions Eliminated: 882 pounds**
> **Water Saved: 4,245 gallons • Solid Waste Eliminated: 258 pounds**

For more information on our environmental practices, please visit us online at www.doverpublications.com/green

By Alan Weller.
Designed by Joel Waldrep.

Wings is a new work, first published by Dover Publications, Inc., in 2010.

For permission to use more than ten images, please contact:
Permissions Department
Dover Publications, Inc.
31 East 2nd Street
Mineola, NY 11501
rights@doverpublications.com

The CD-ROM file names correspond to the images in the book. All of the artwork stored on the CD-ROM can be imported directly into a wide range of design and word-processing programs on either Windows or Macintosh platforms. No further installation is necessary.

ISBN 10: 0-486-99081-8
ISBN 13: 978-0-486-99081-1
Manufactured in the United States of America
Dover Publications, Inc., 31 East 2nd Street, Mineola, NY 11501
www.doverpublications.com

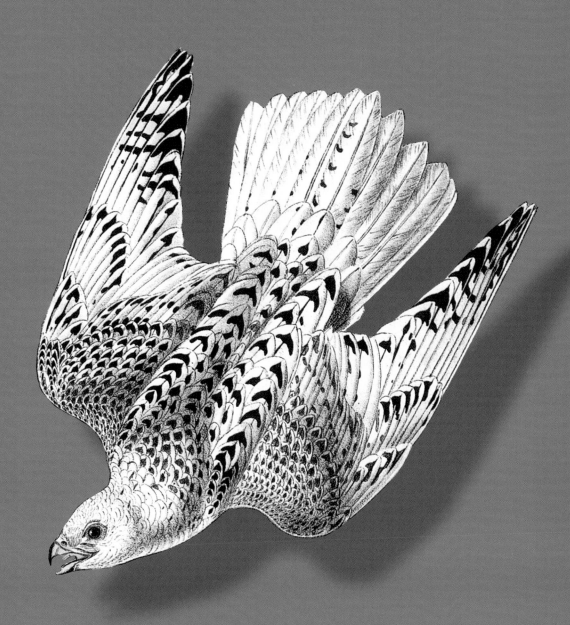

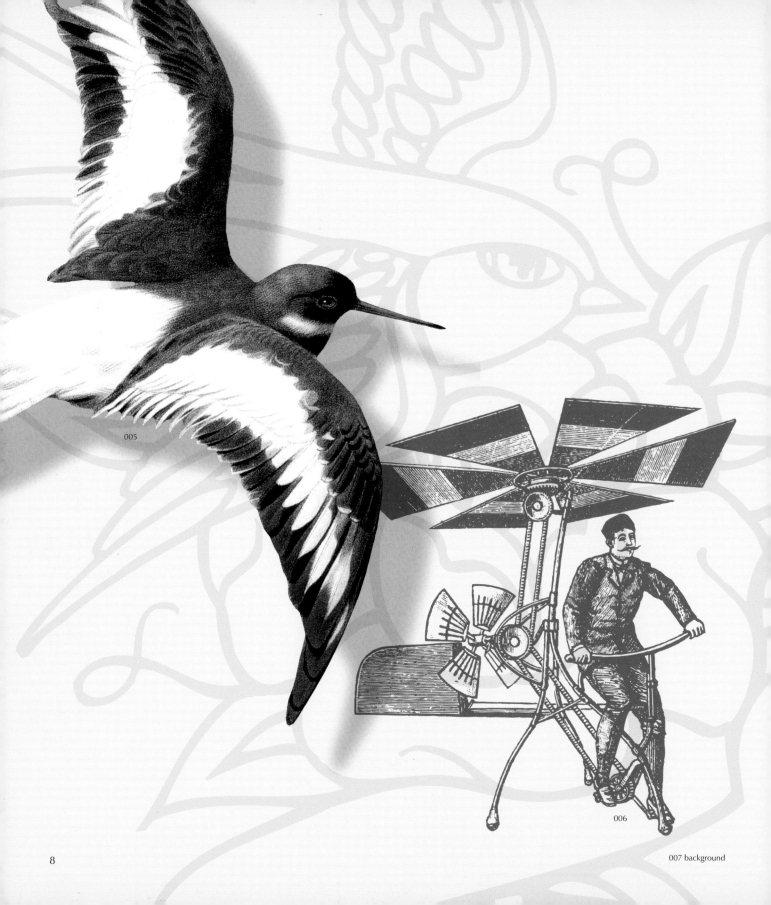

005

006

8

007 background

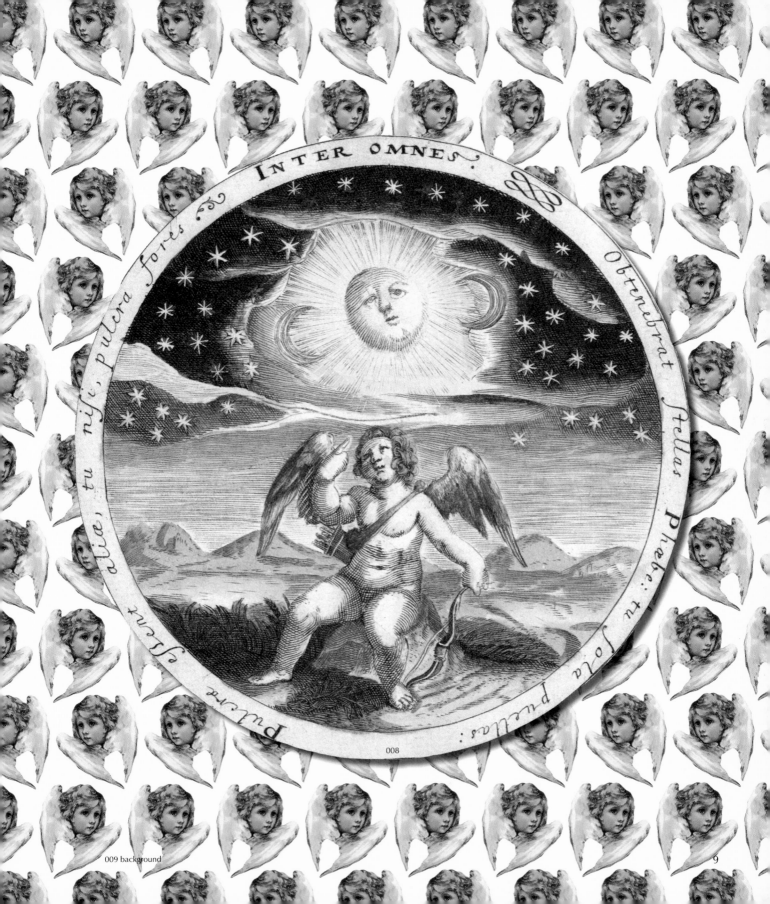

INTER OMNES.

Obtenebrat Stellas Phæbe; tu sola puellas: Pulcræ essent aliæ, tu nisi, pulcra fores.

008

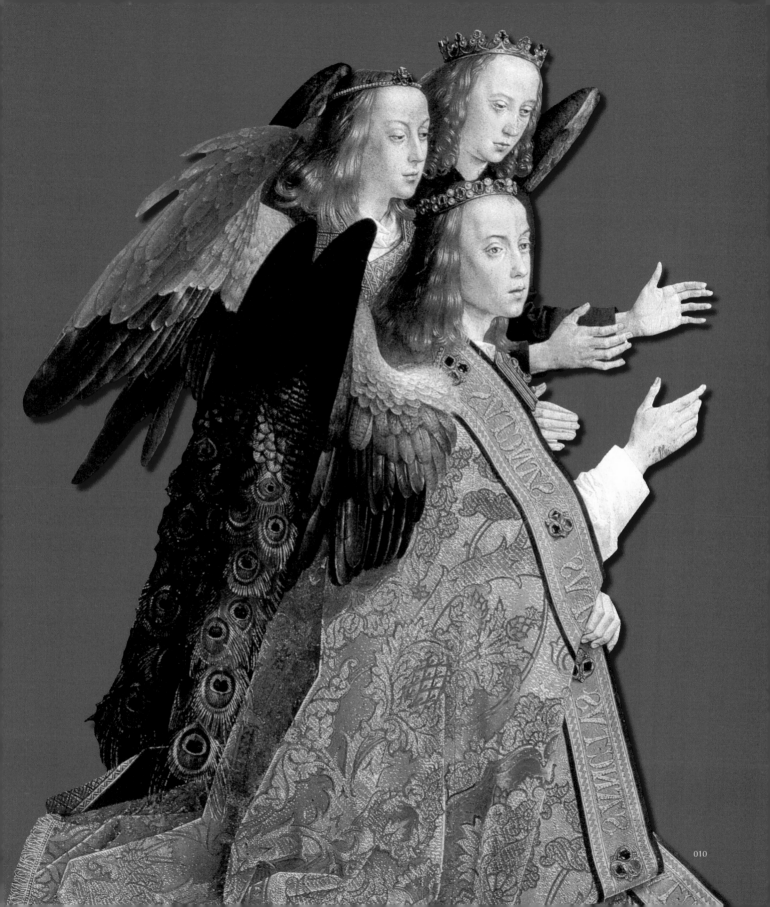

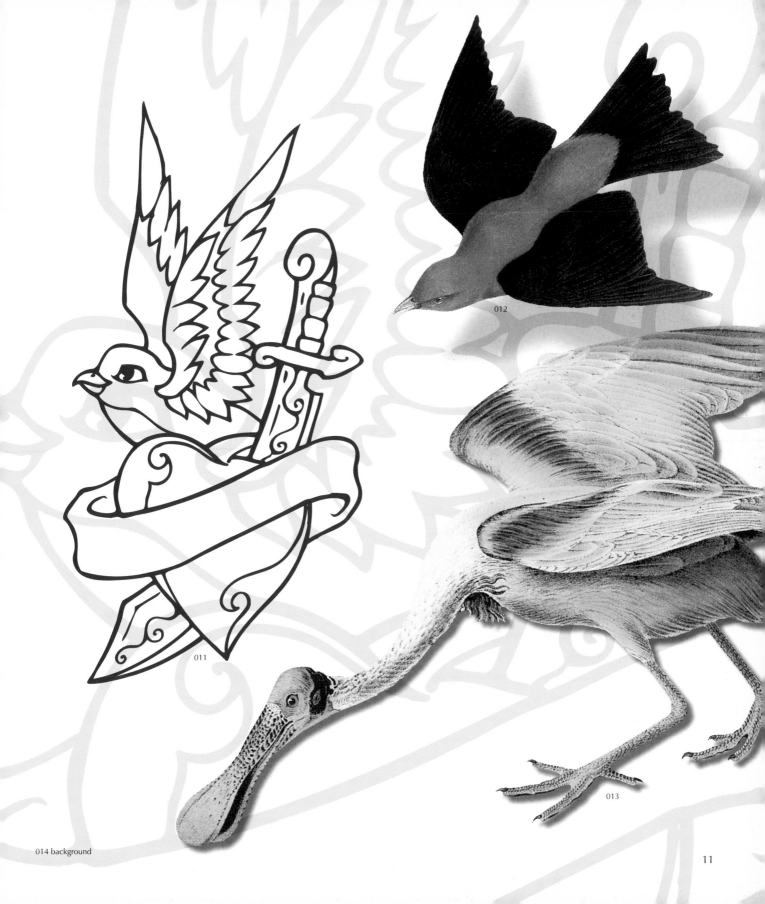

011

012

013

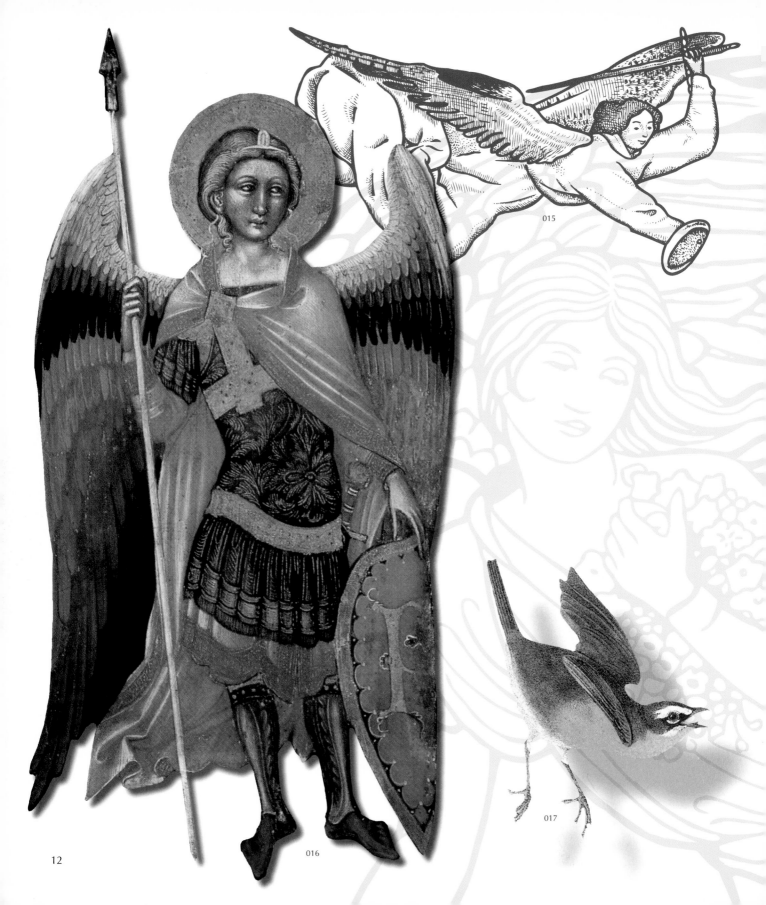

015

016

017

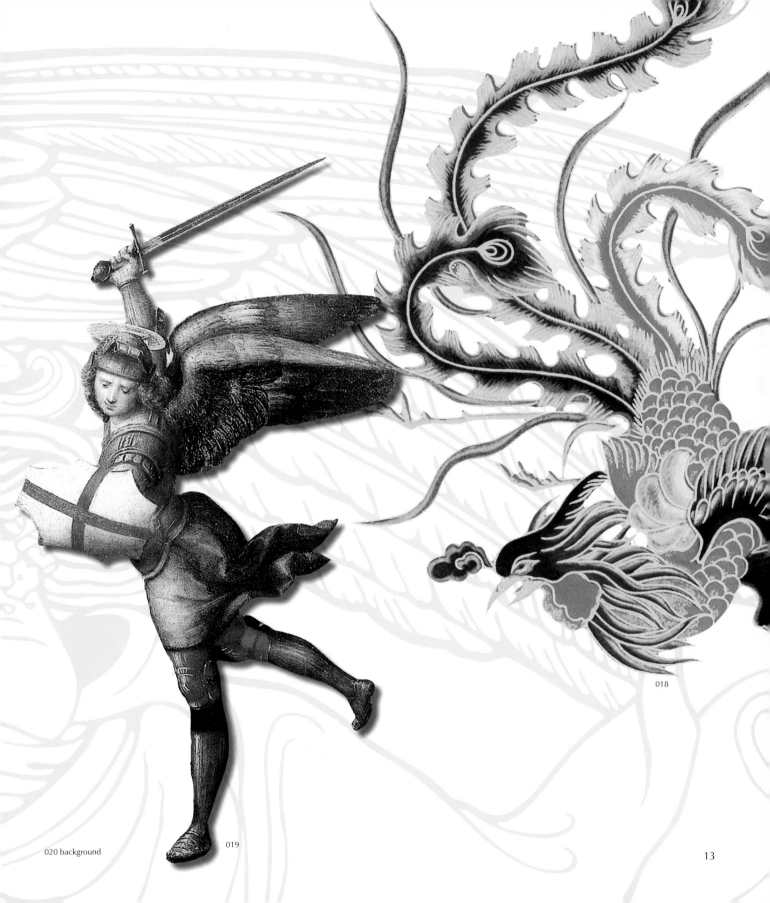

018

020 background 019

13

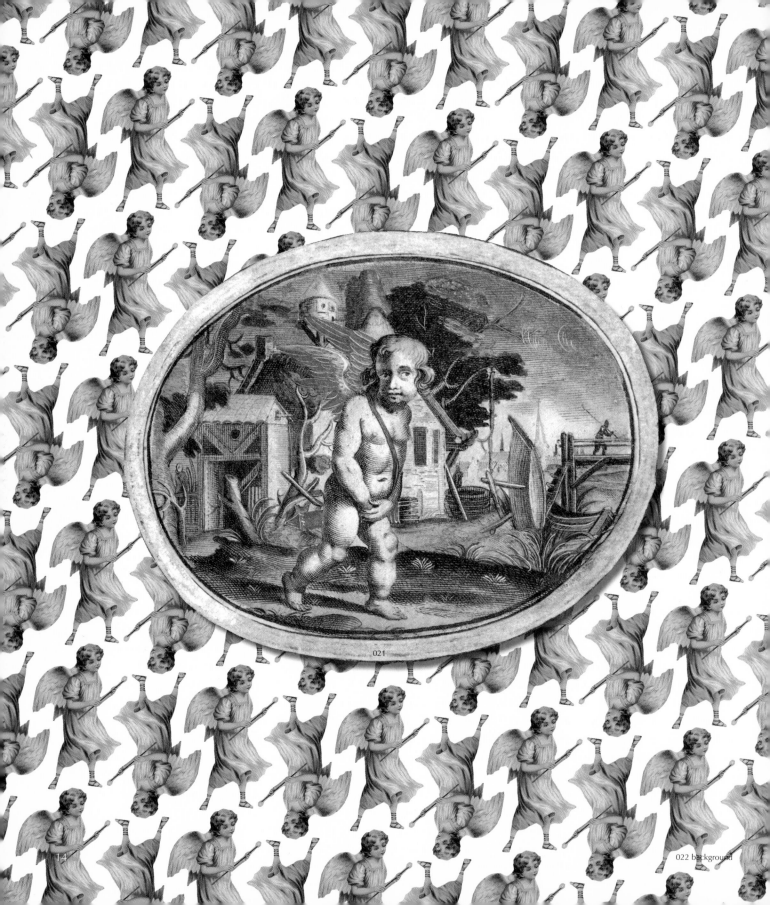

021

022 background

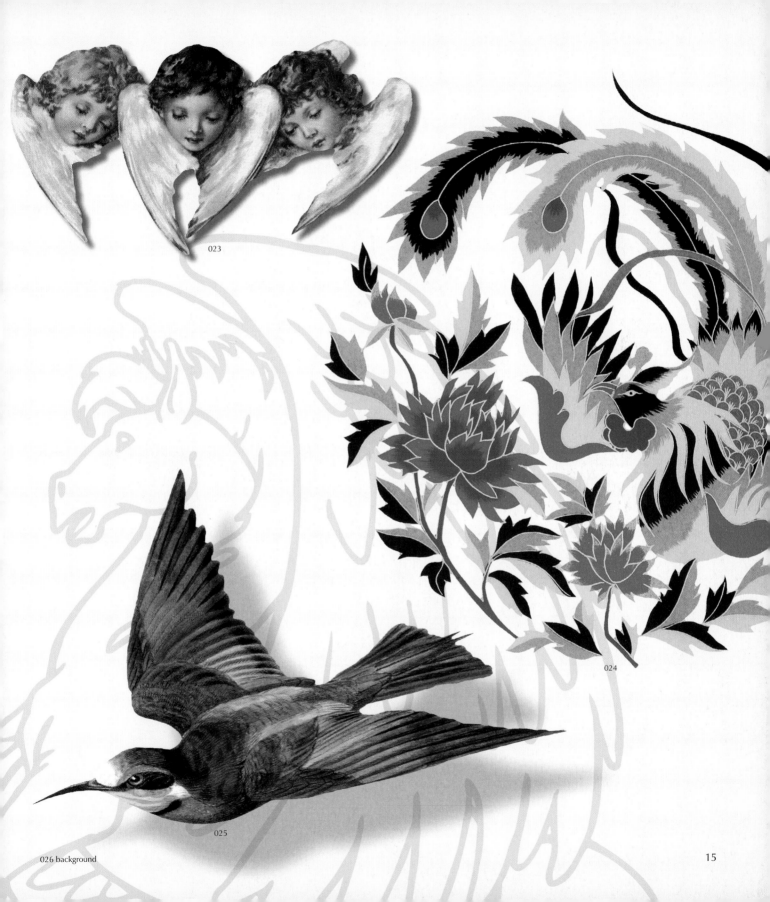

023

024

025

026 background

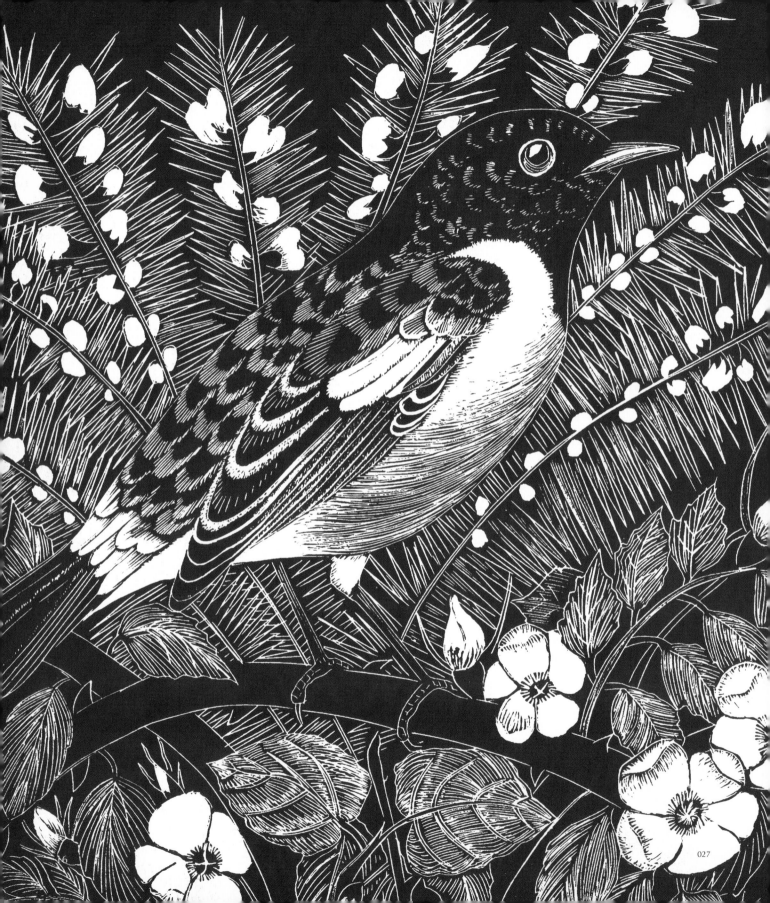

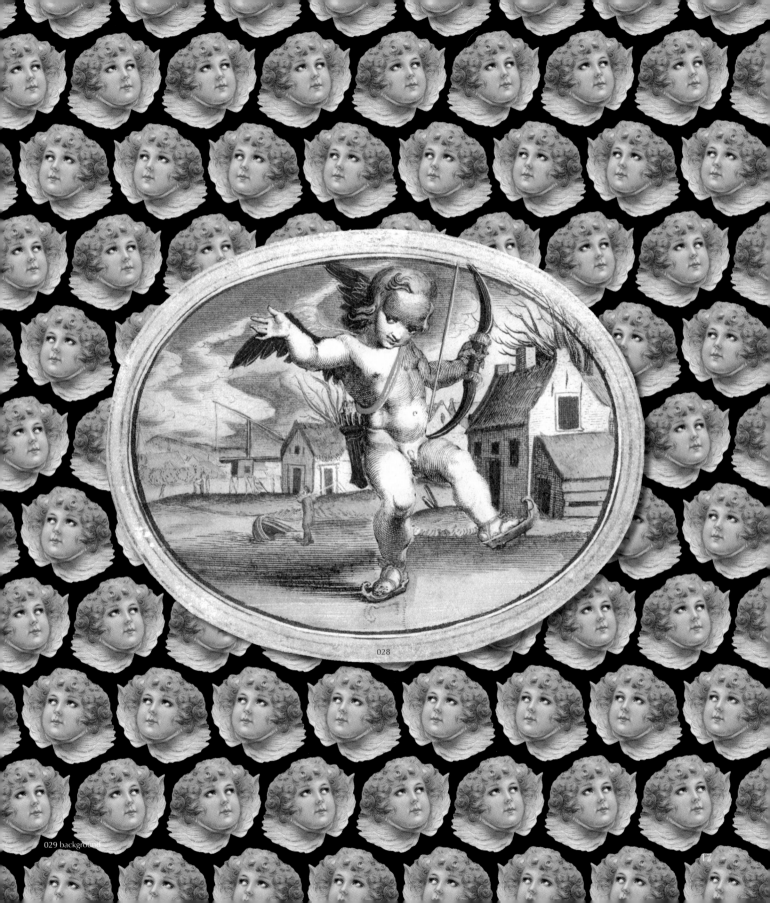

028

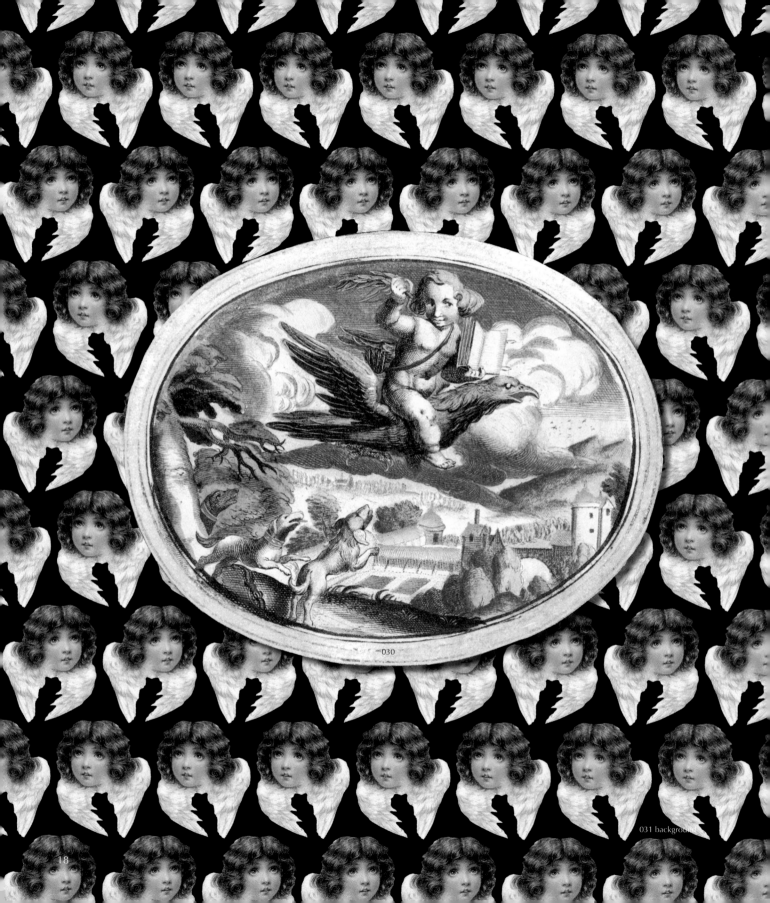

030

031 background

032

033

034

035 background

19

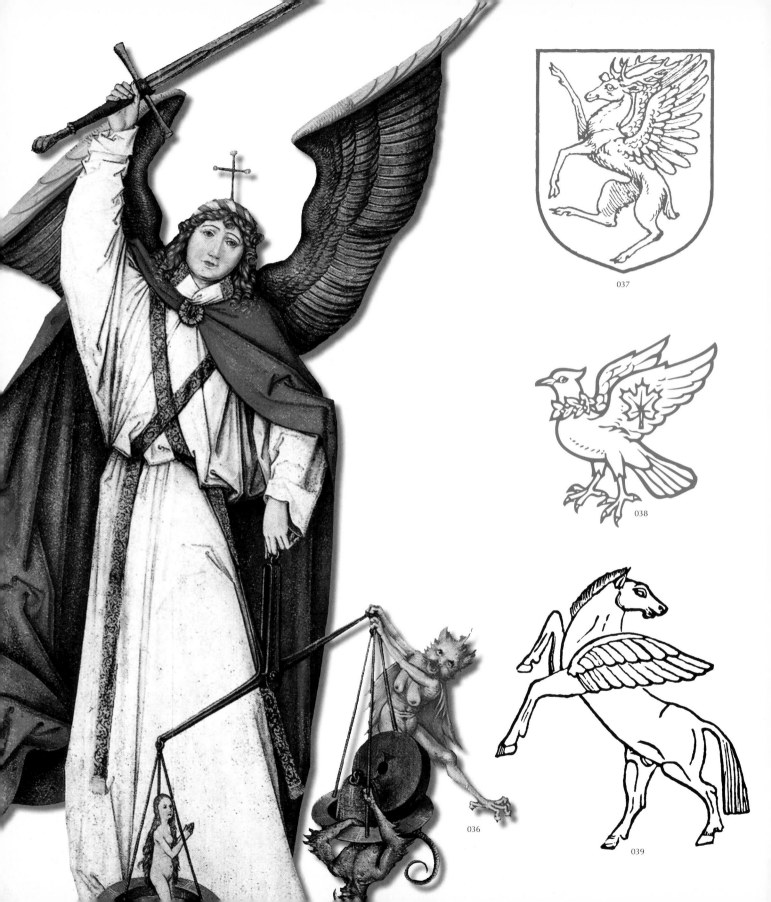

037

038

036

039

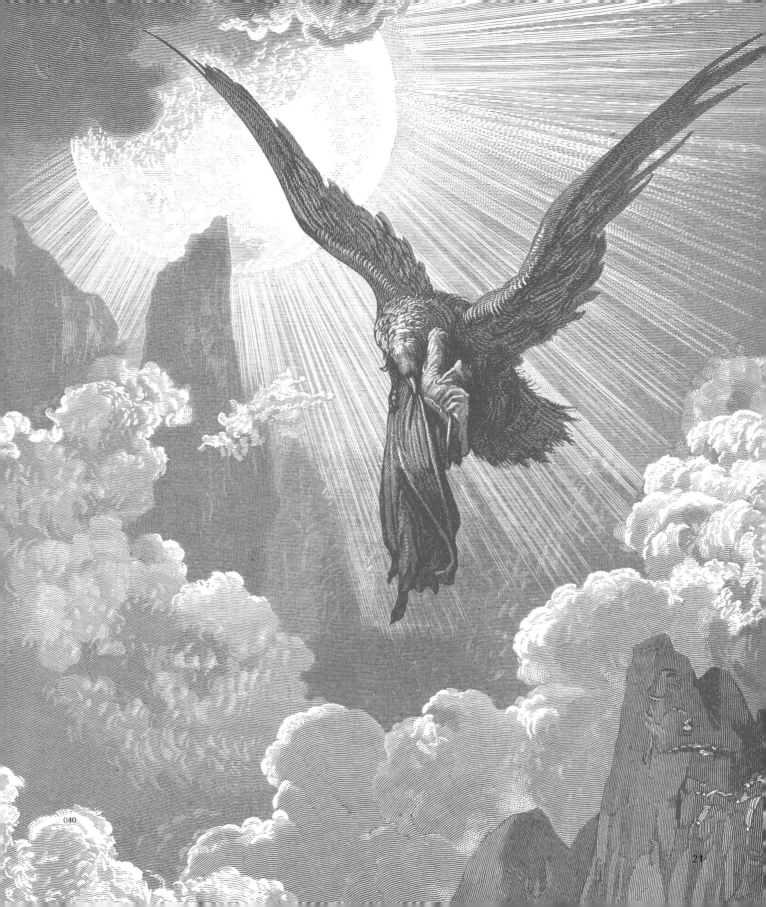

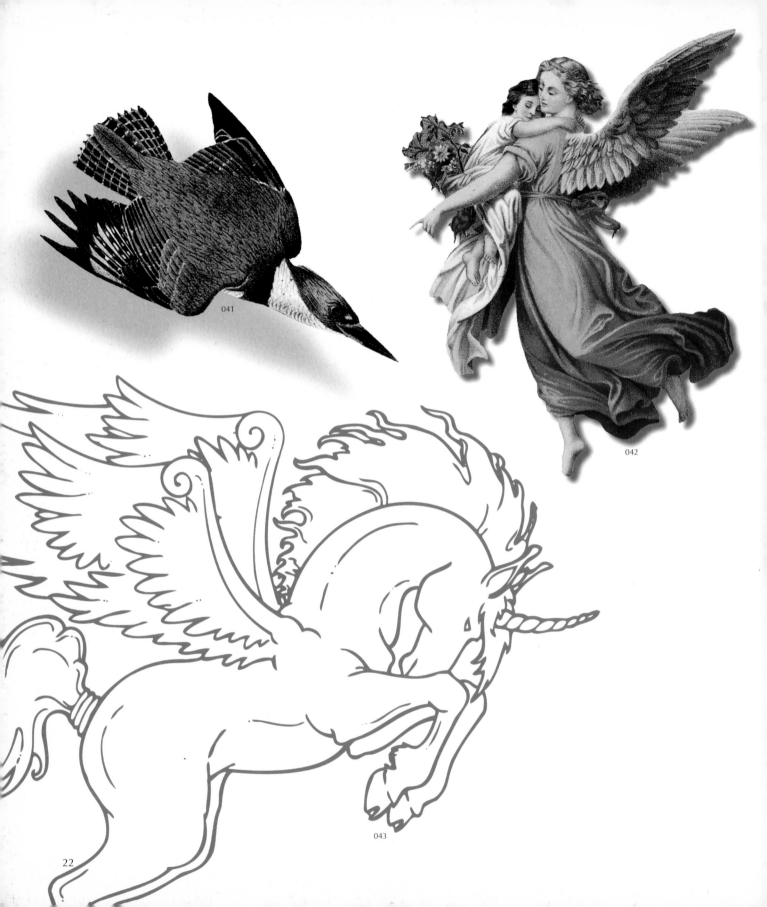

041

042

043

044

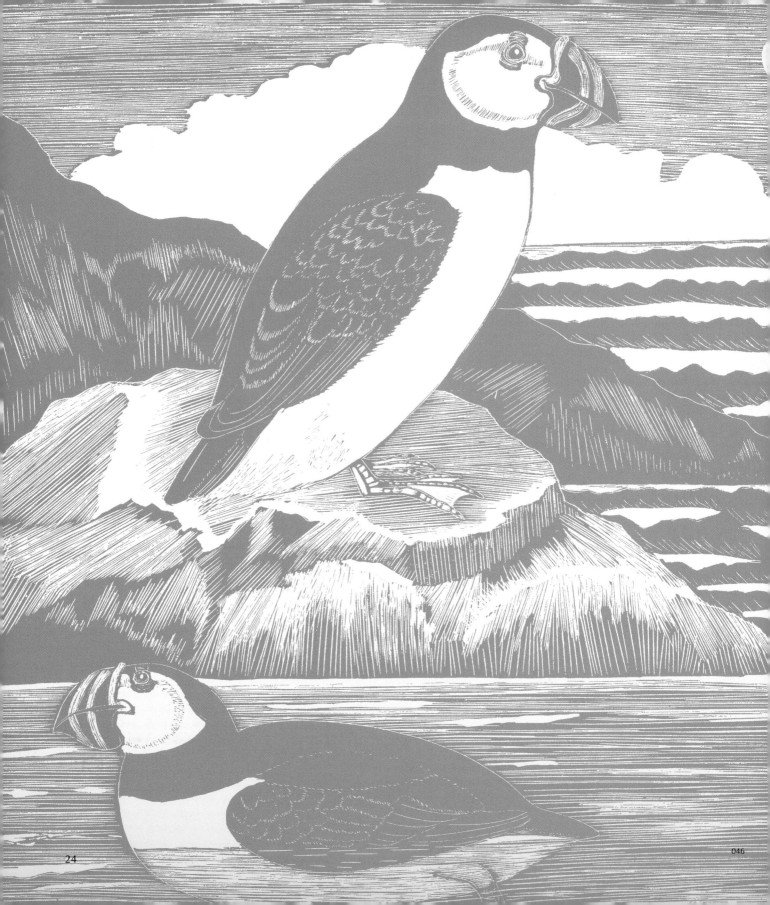

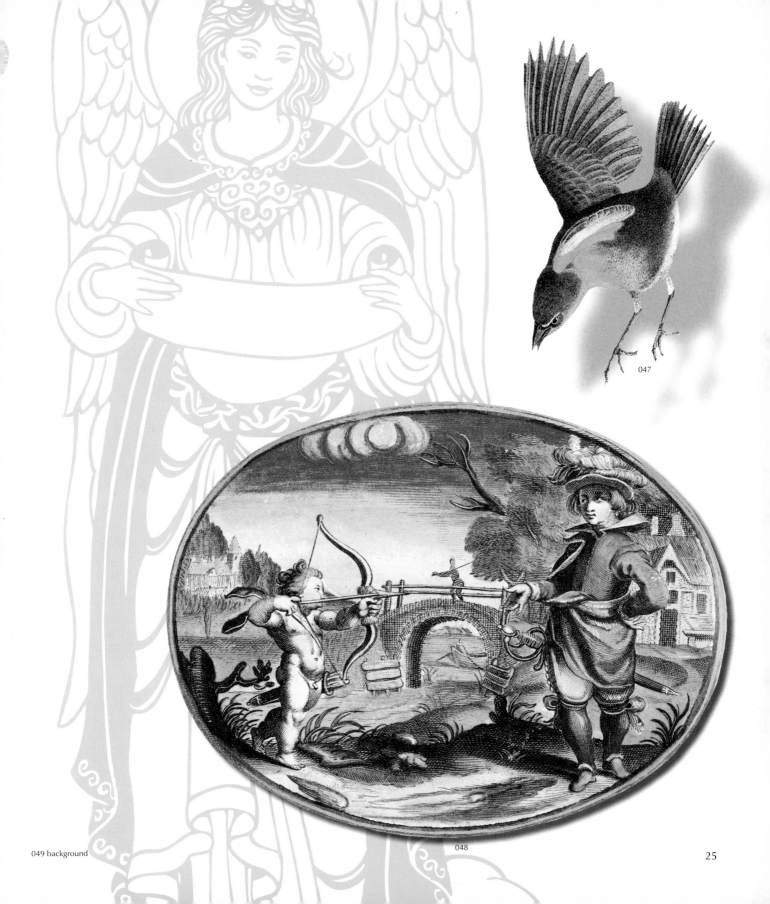

047

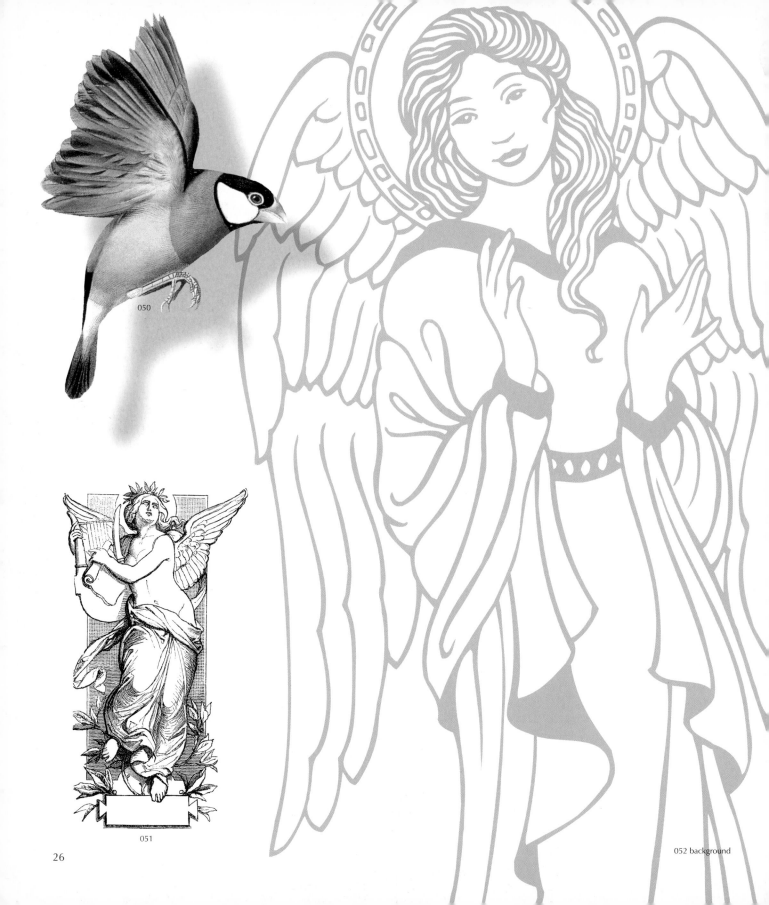

050

051

052 background

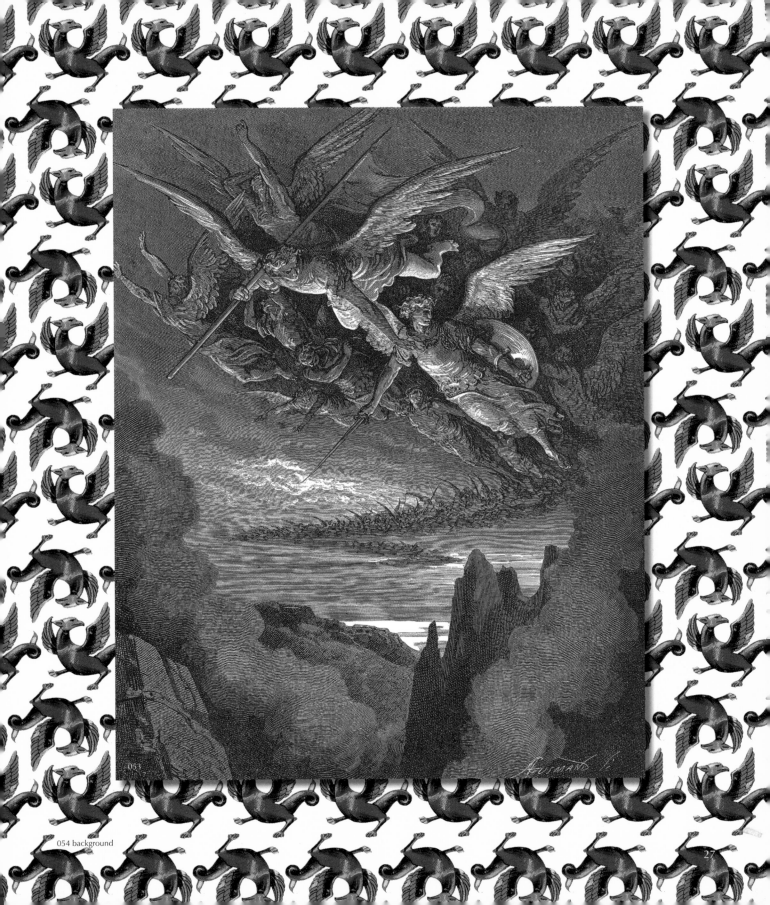

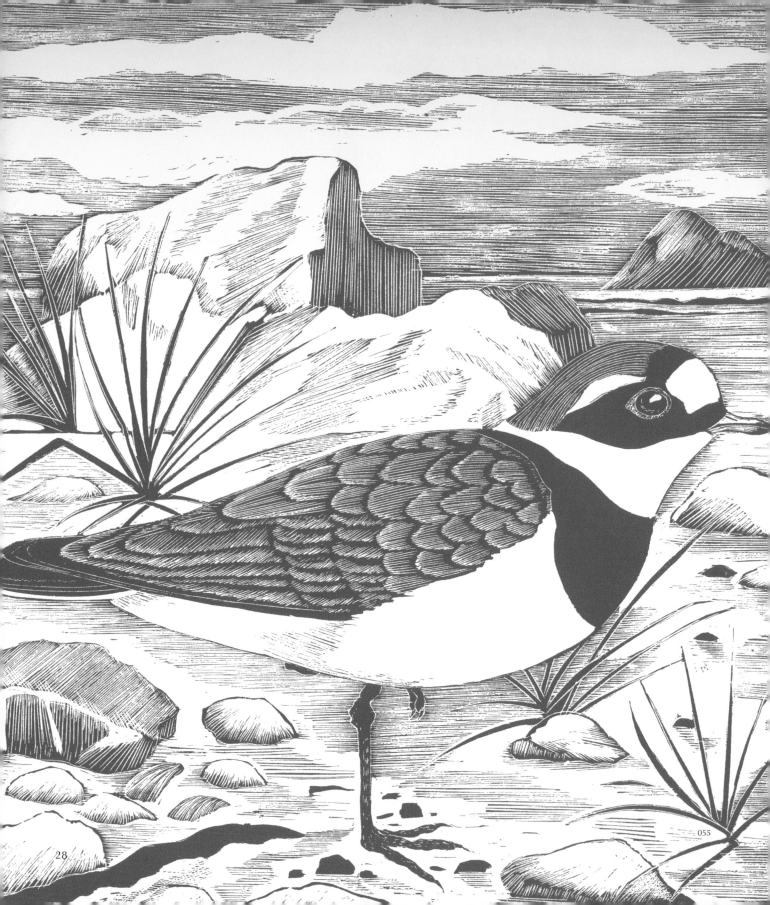

055

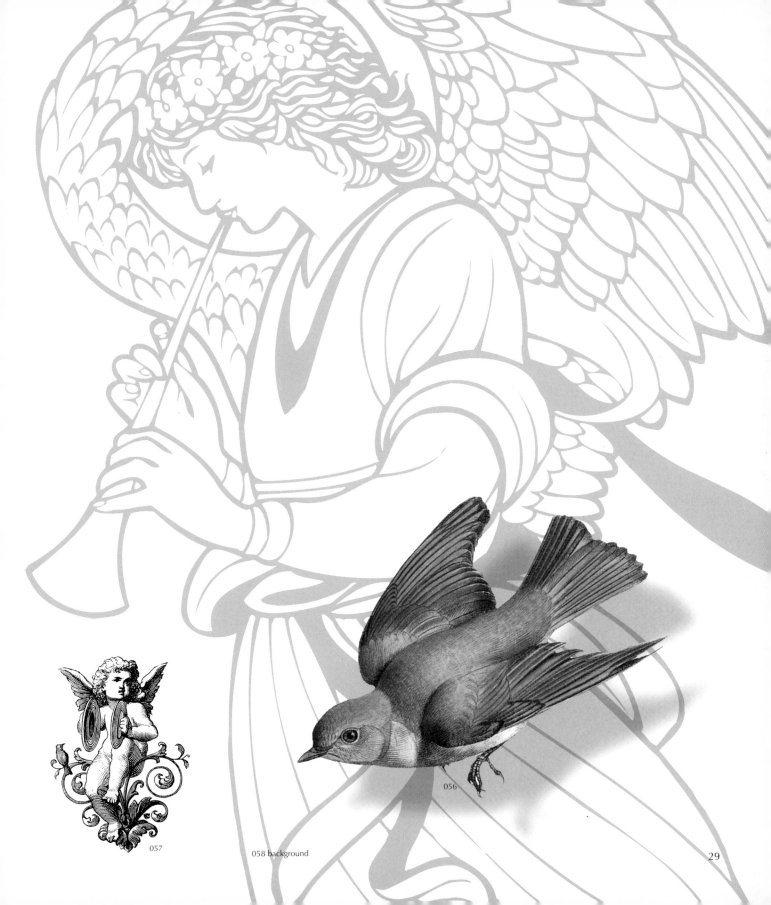

057

058 background

056

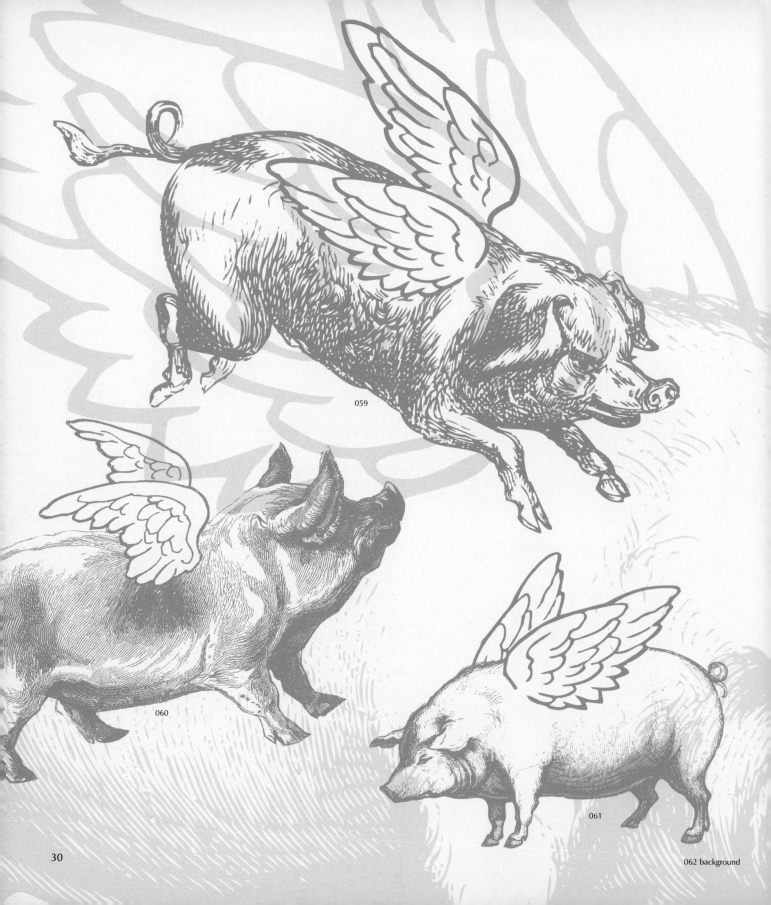

059

060

061

062 background

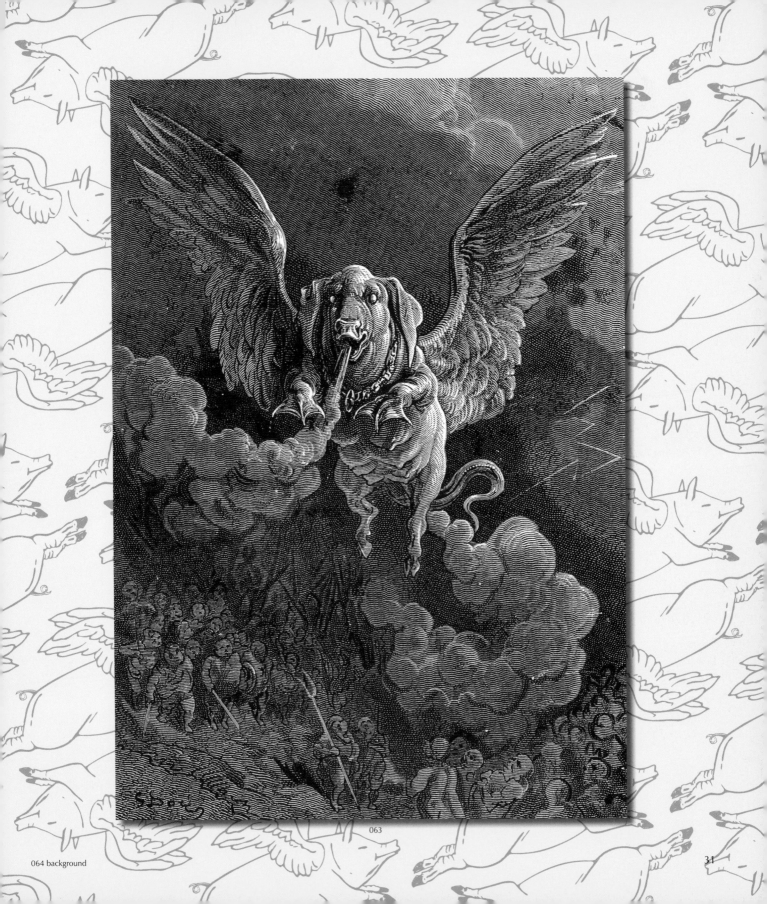

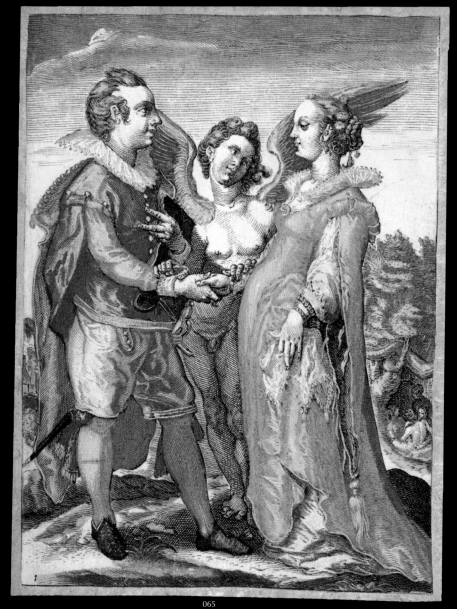

065

32

066

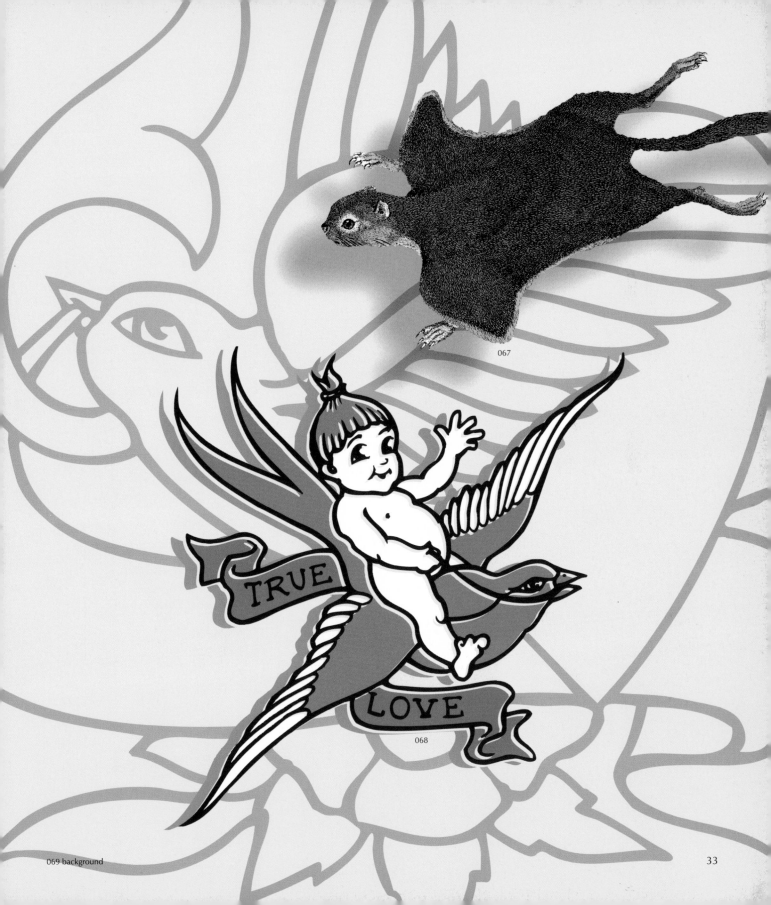

067

TRUE

LOVE

068

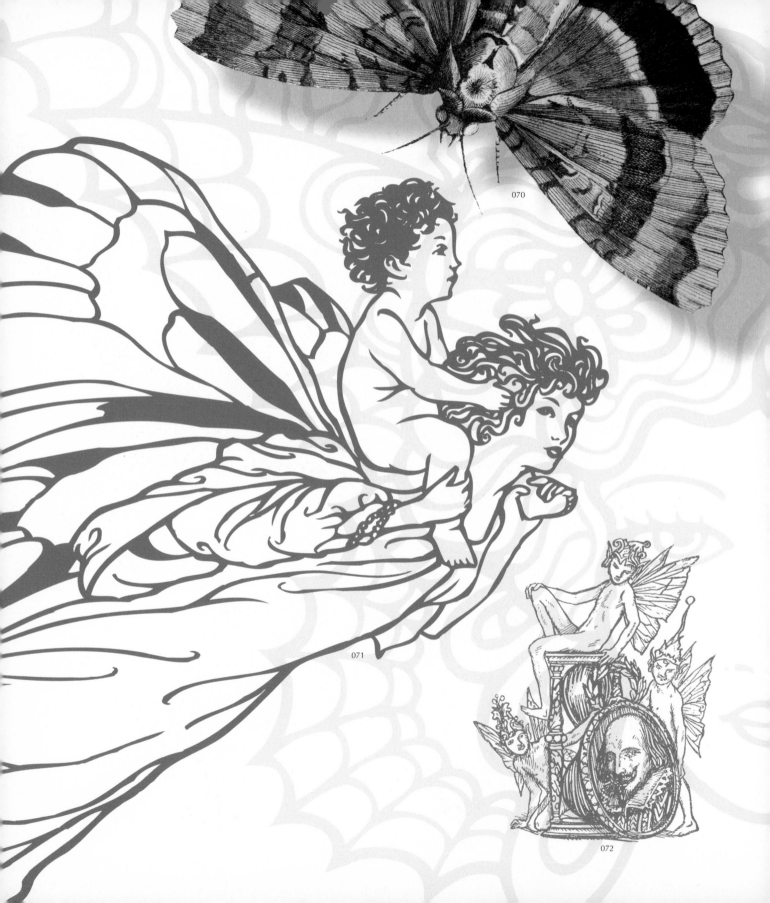

070

071

072

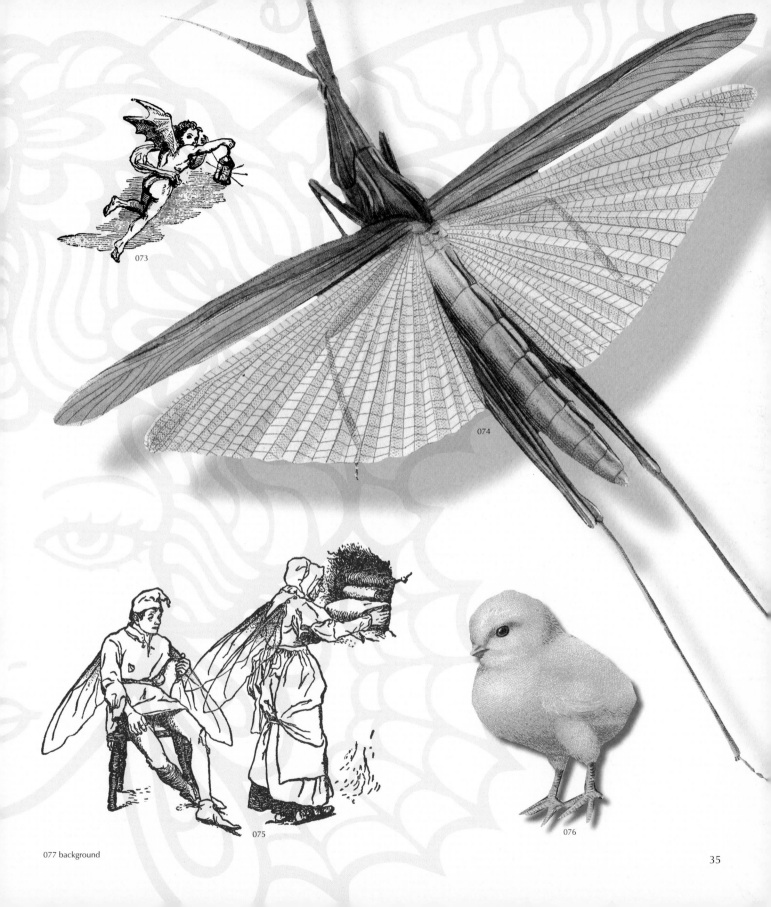

073

074

075

076

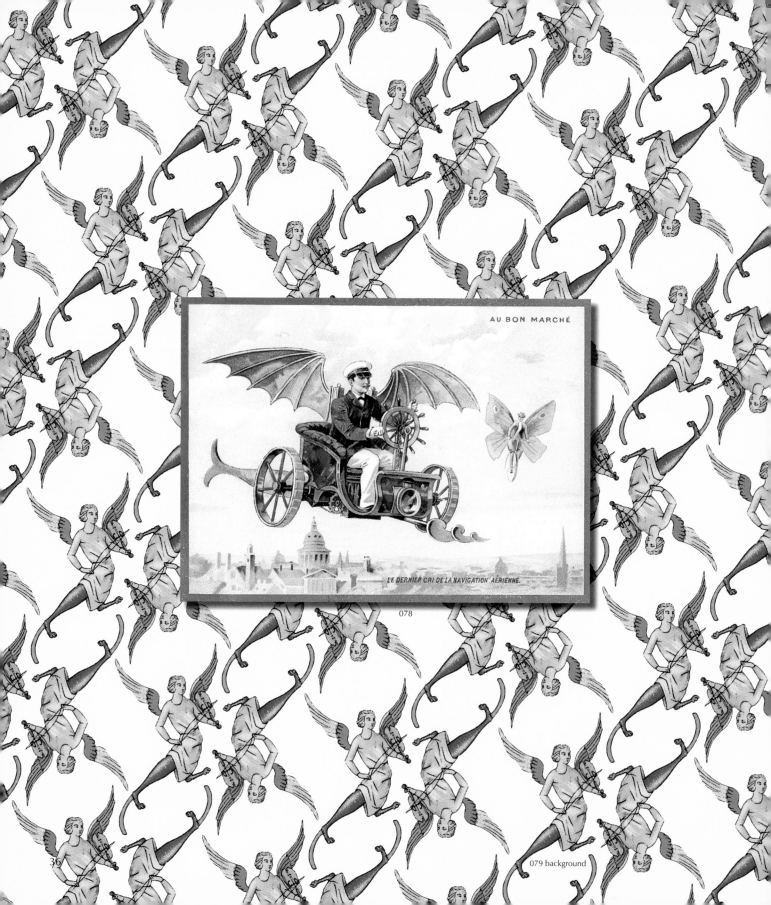

AU BON MARCHÉ

LE DERNIER CRI DE LA NAVIGATION AÉRIENNE.

078

079 background

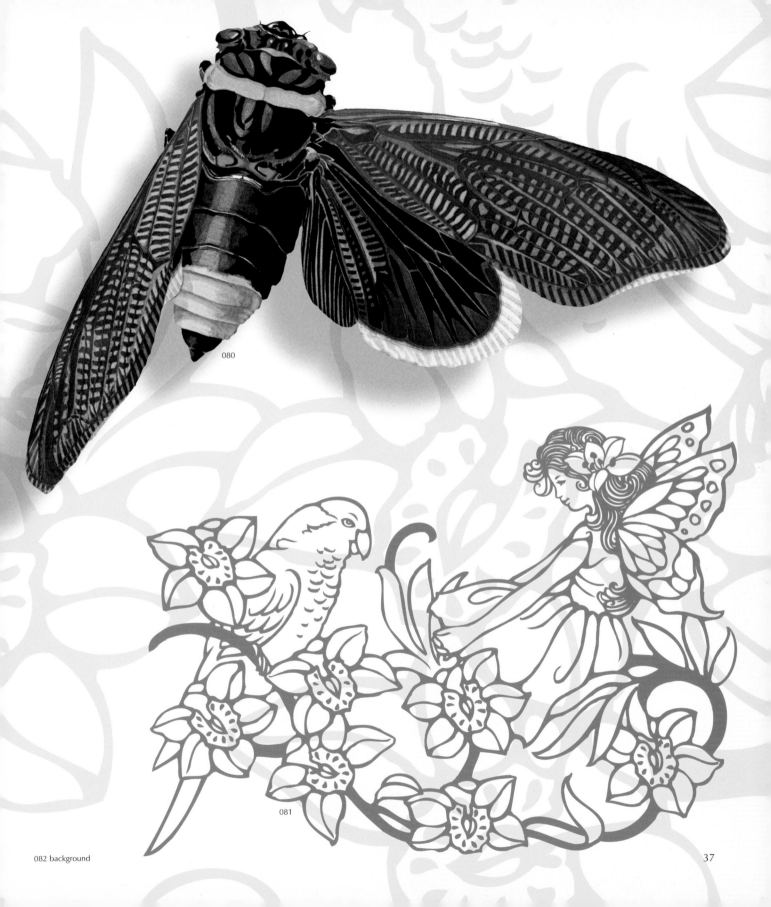

080

081

082 background

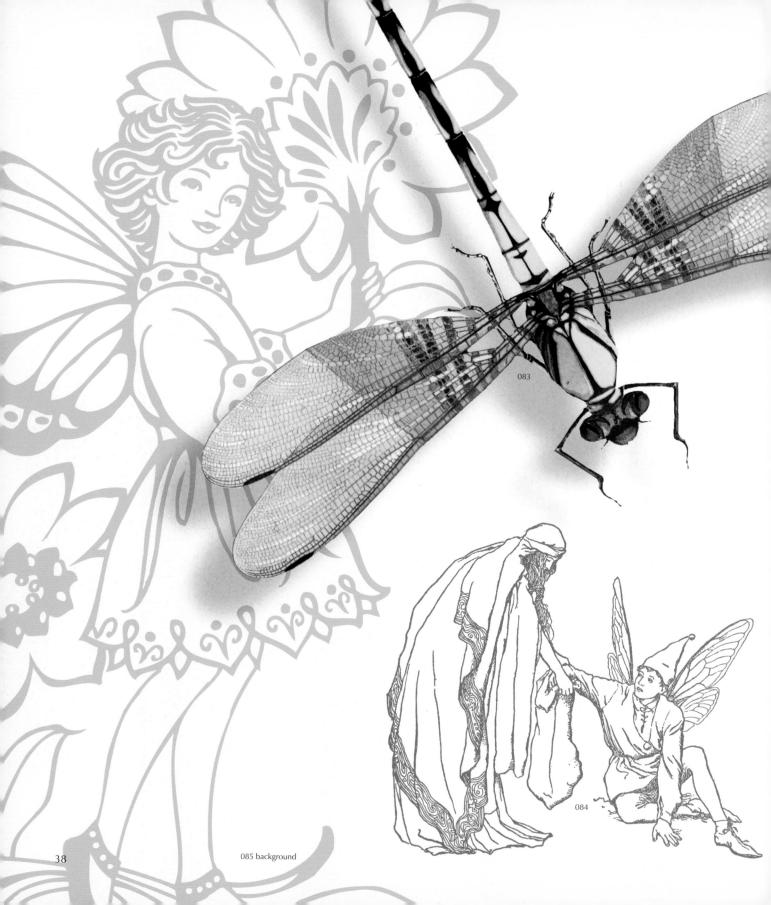

083

084

085 background

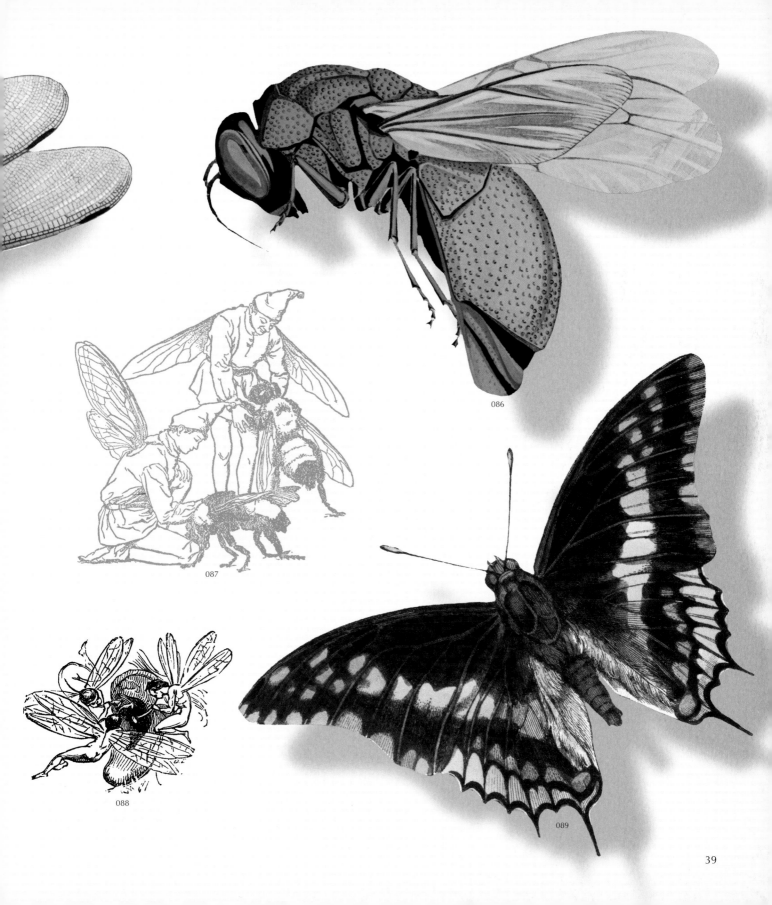

086

087

088

089

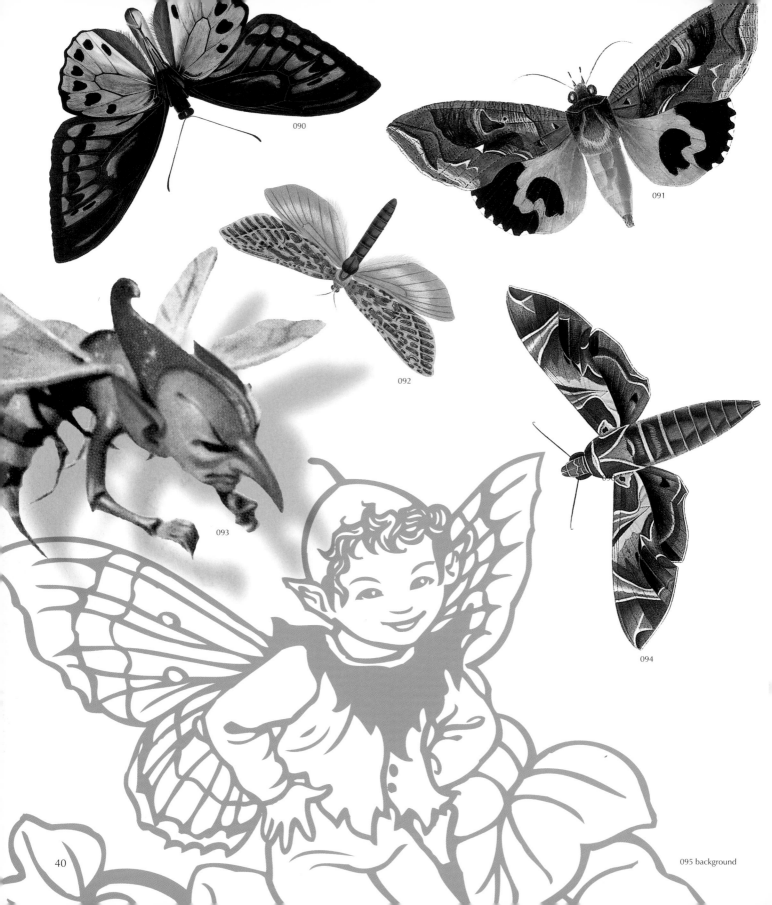

090

091

092

093

094

40

095 background

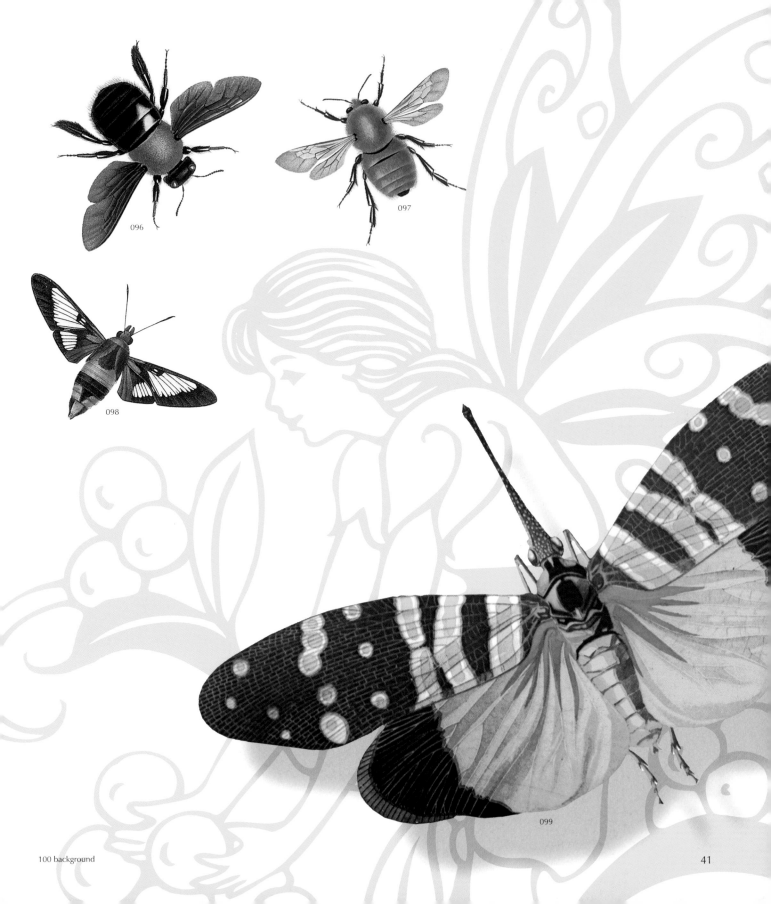

096

097

098

099

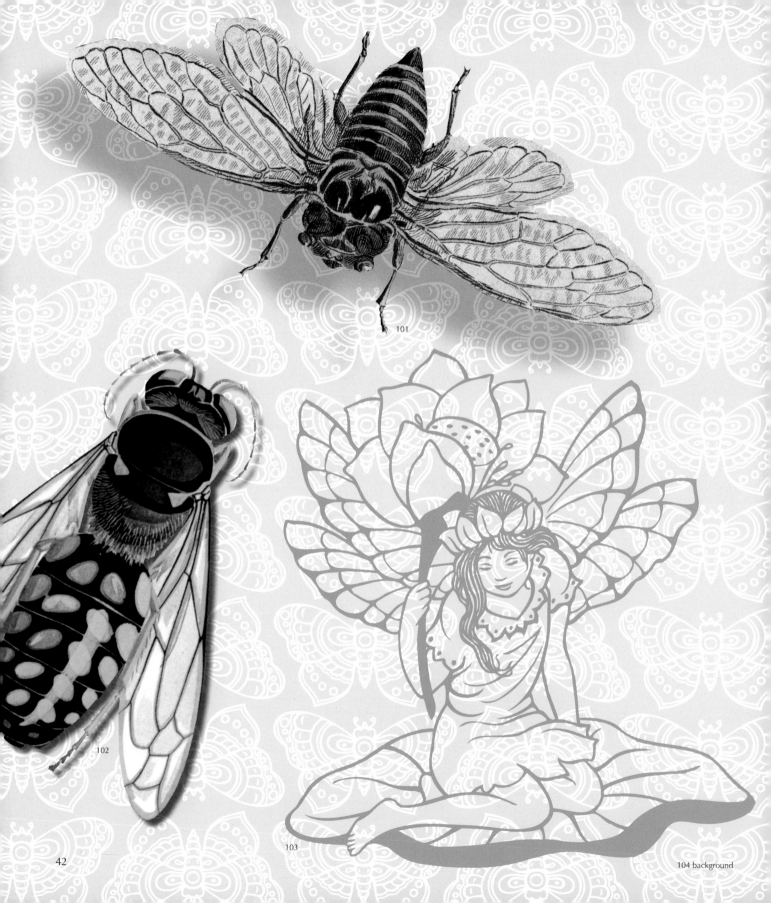

101

102

103

104 background

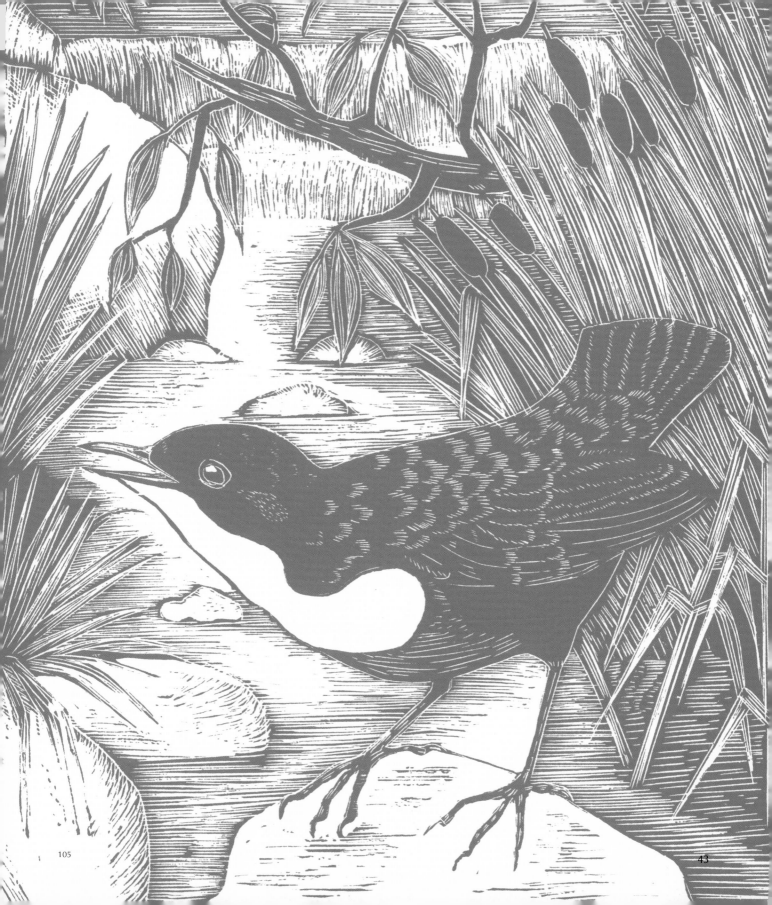

MANUFACTURE ROUBAISIENNE

106

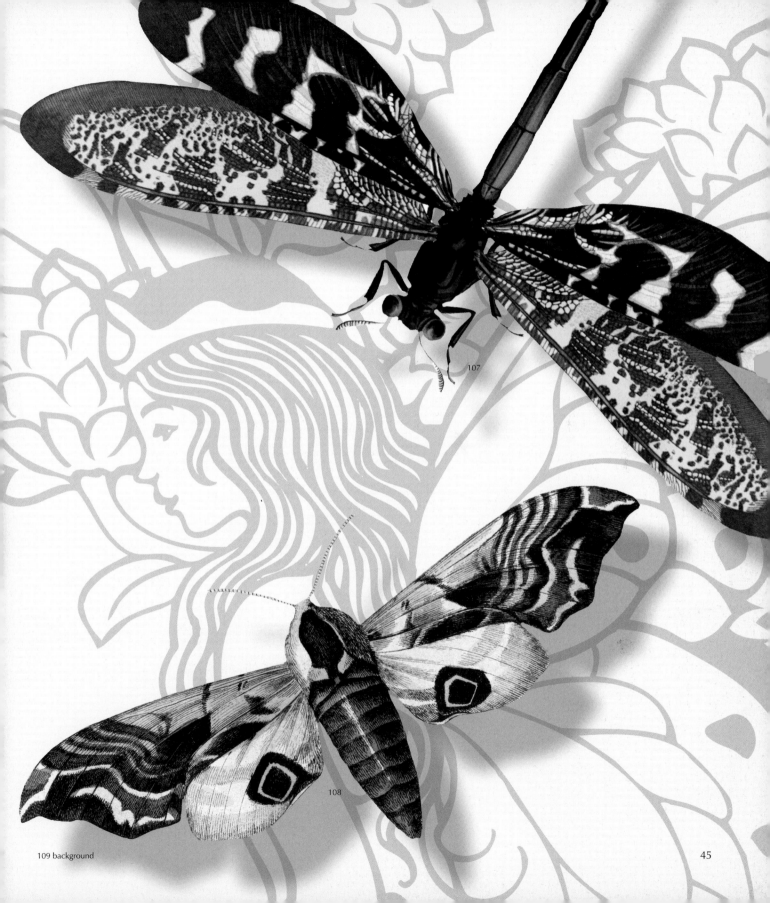

107

108

109 background

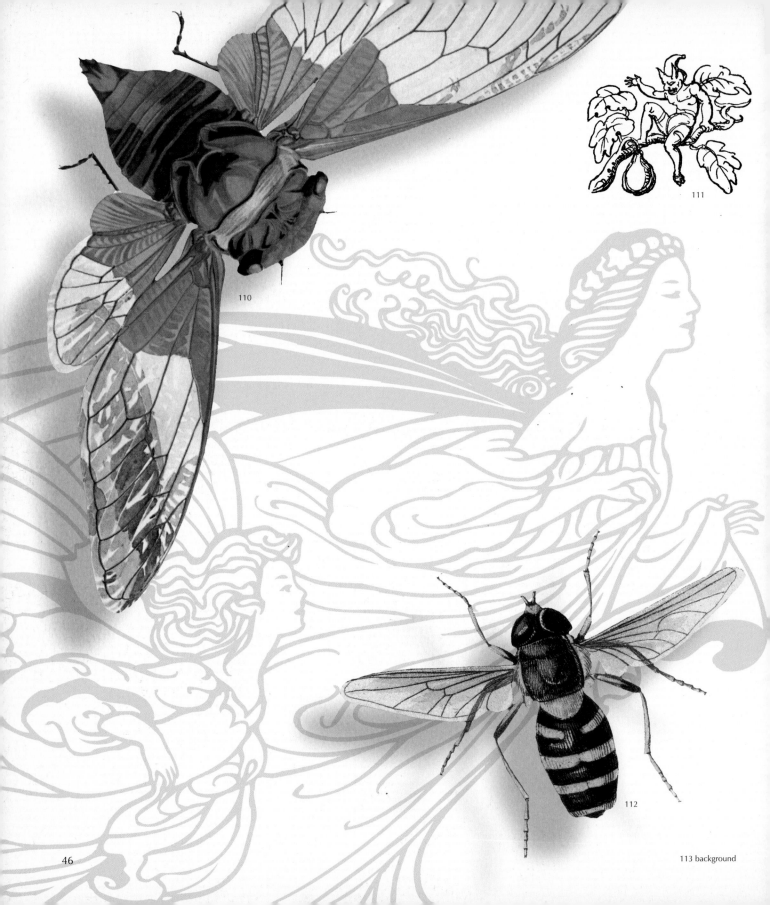

110

111

112

113 background

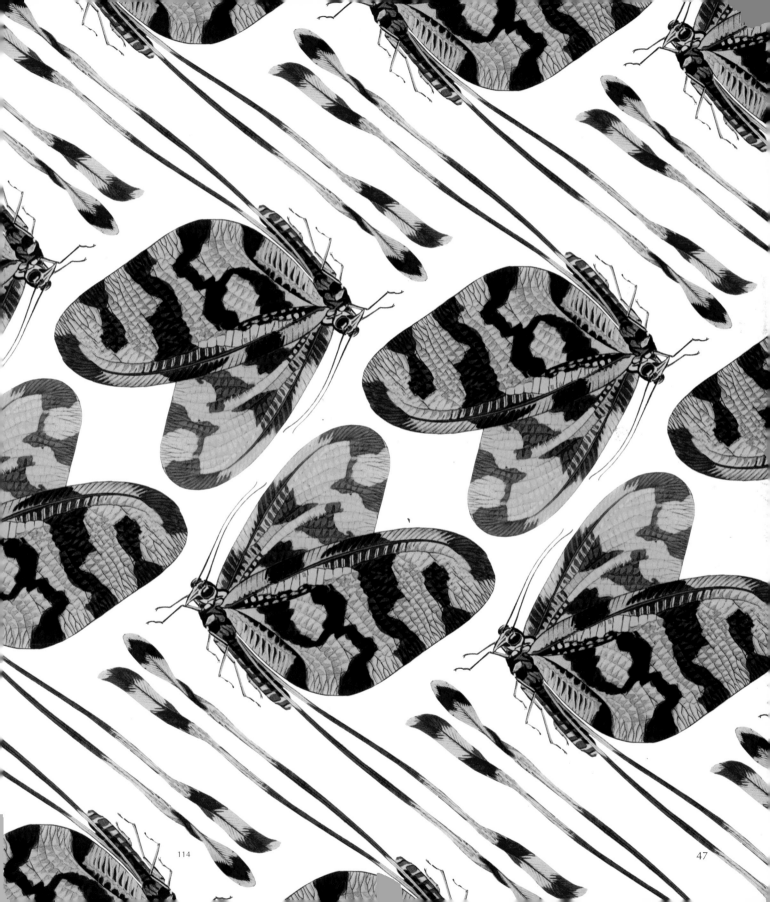

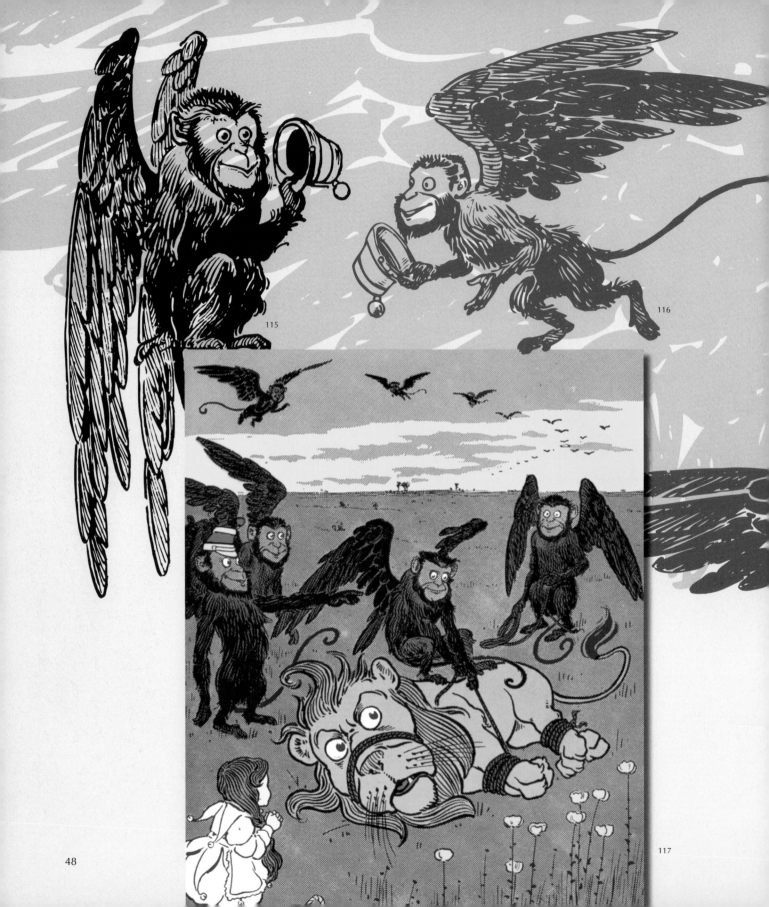

115

116

48

117

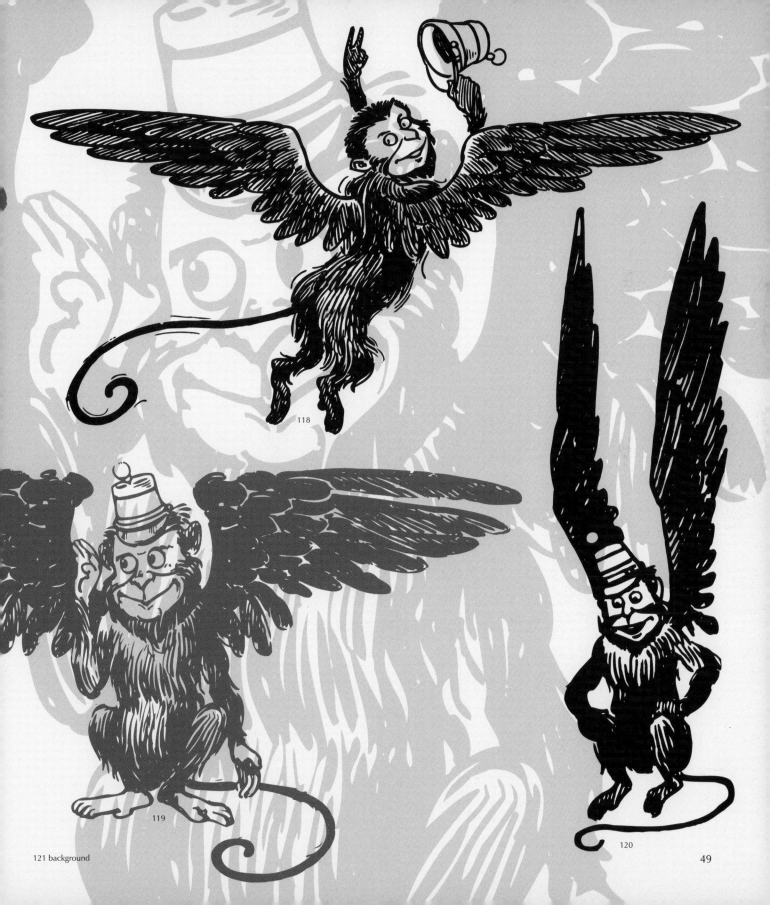

118

119

120

121 background

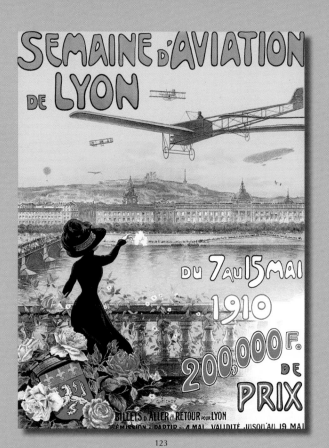

123

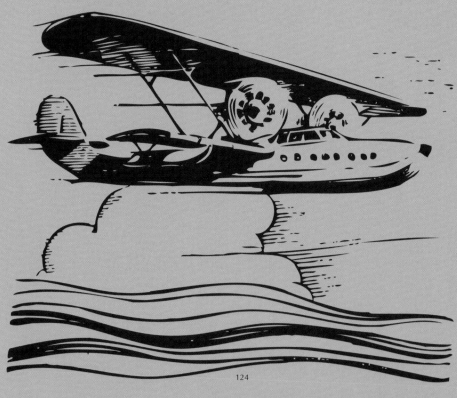

122

124

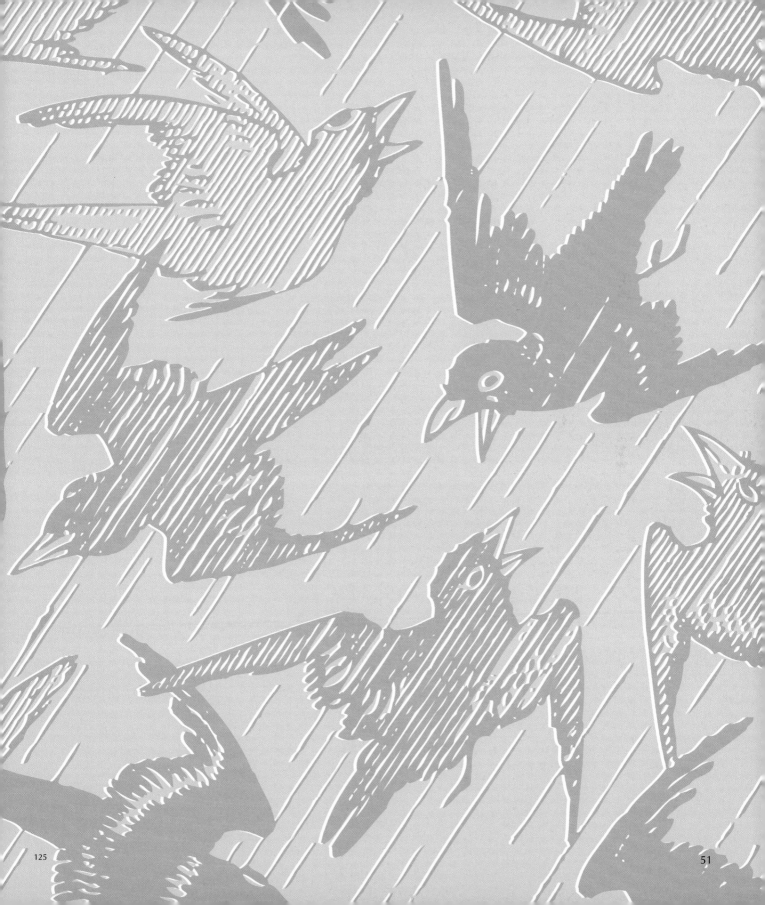

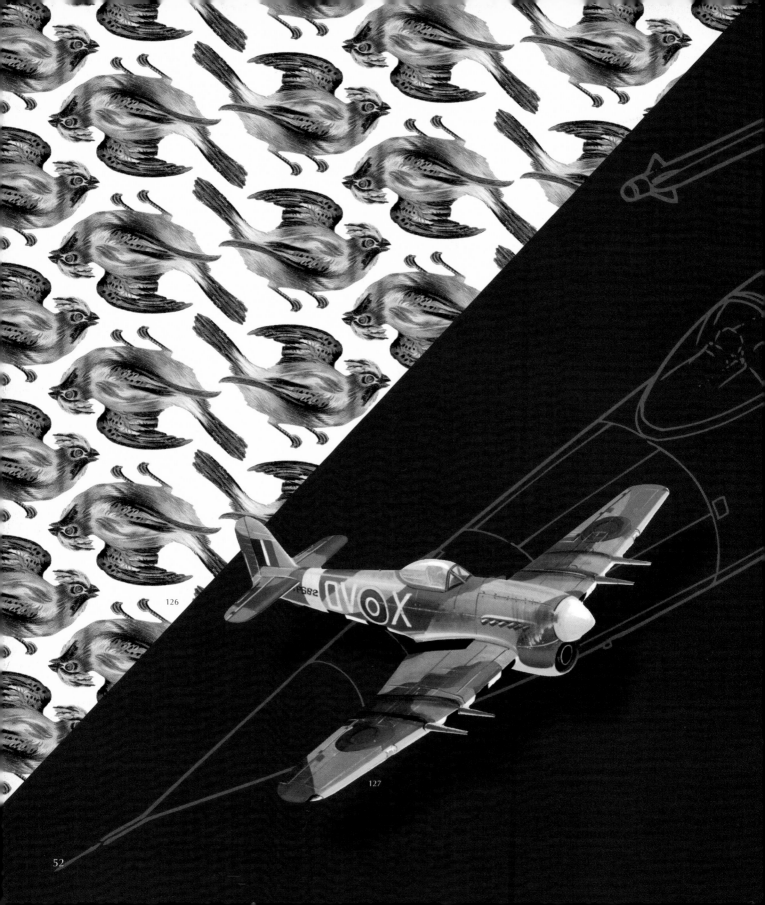

126

127

52

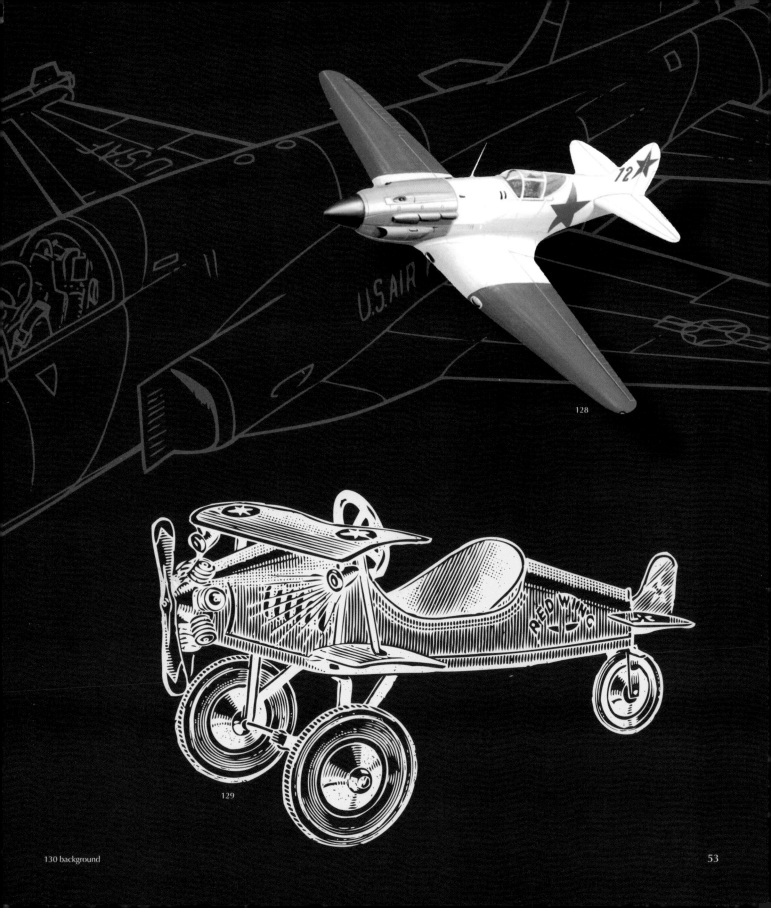

128

129

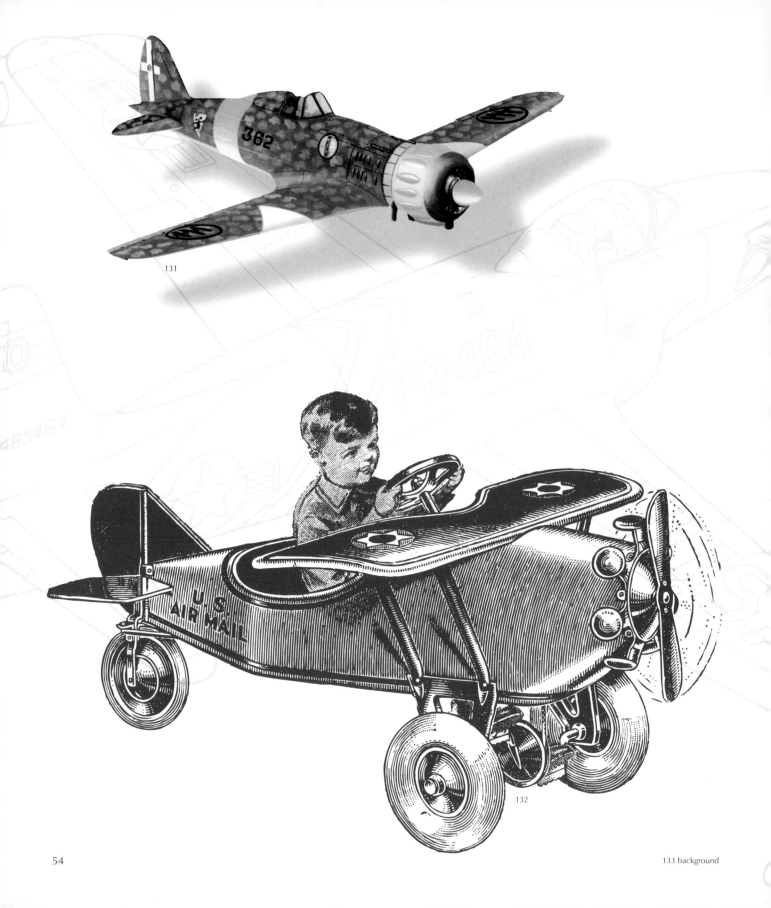

131

132

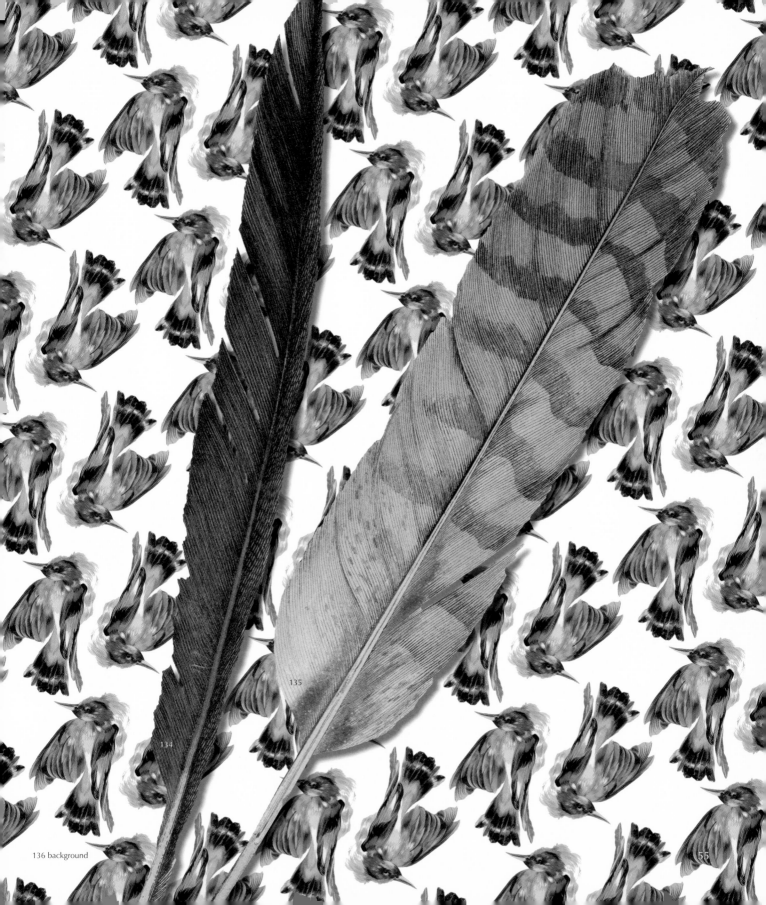

134

135

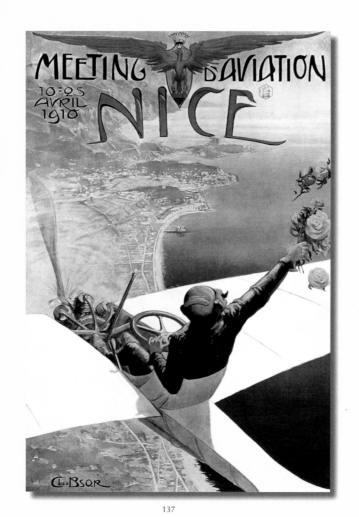

137

138

139

140

56

141

142

143

57

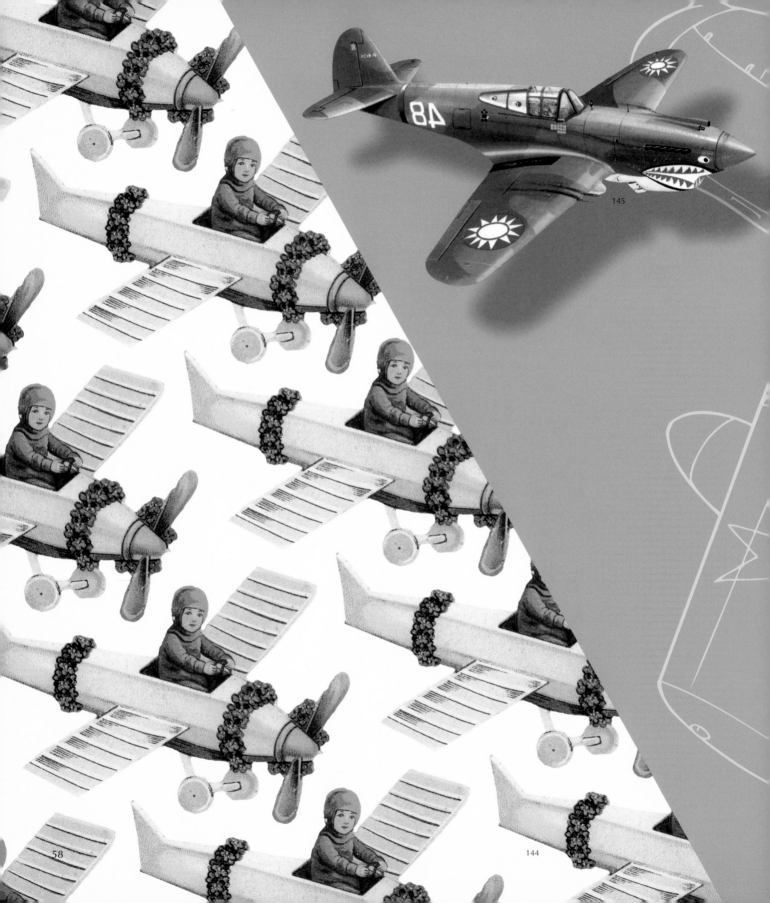

144

145

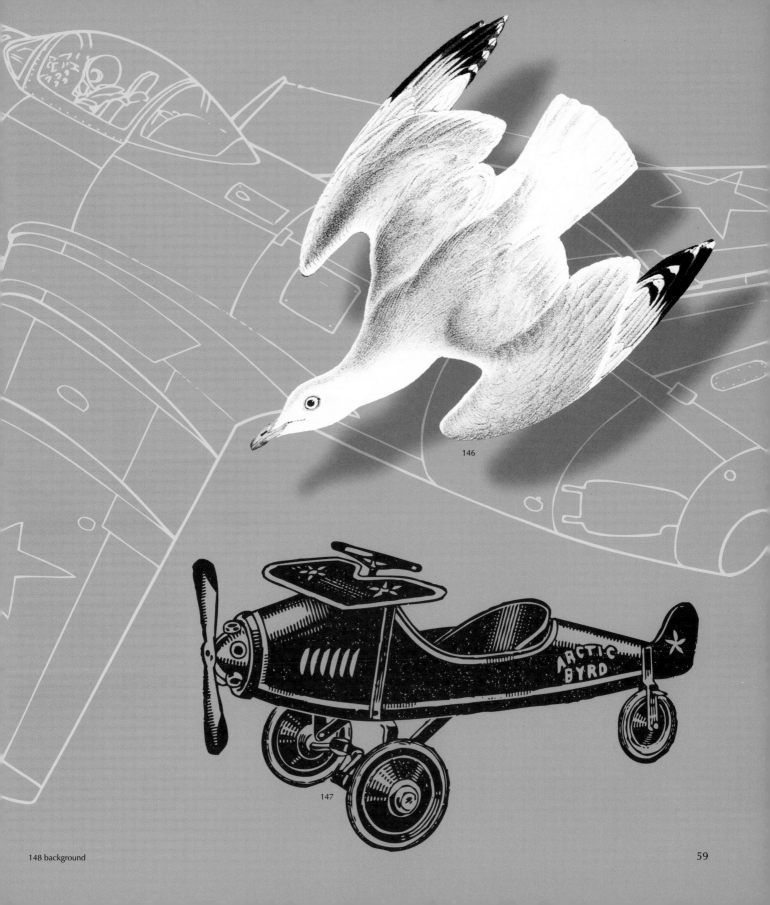

146

ARCTIC BYRD

147

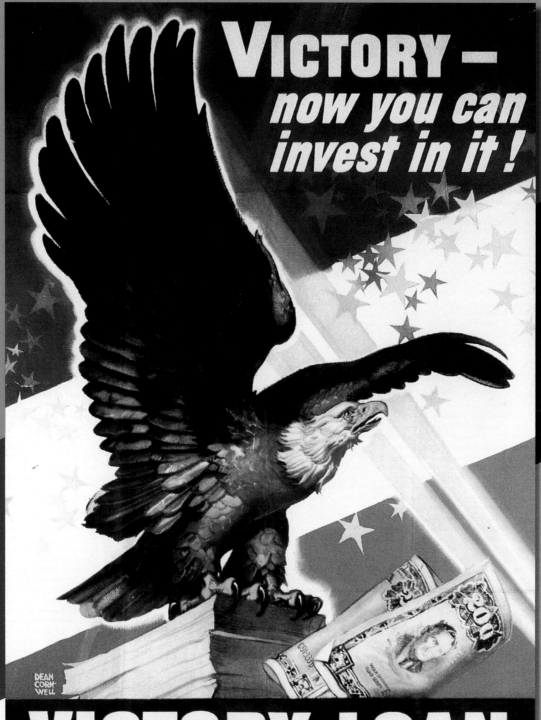

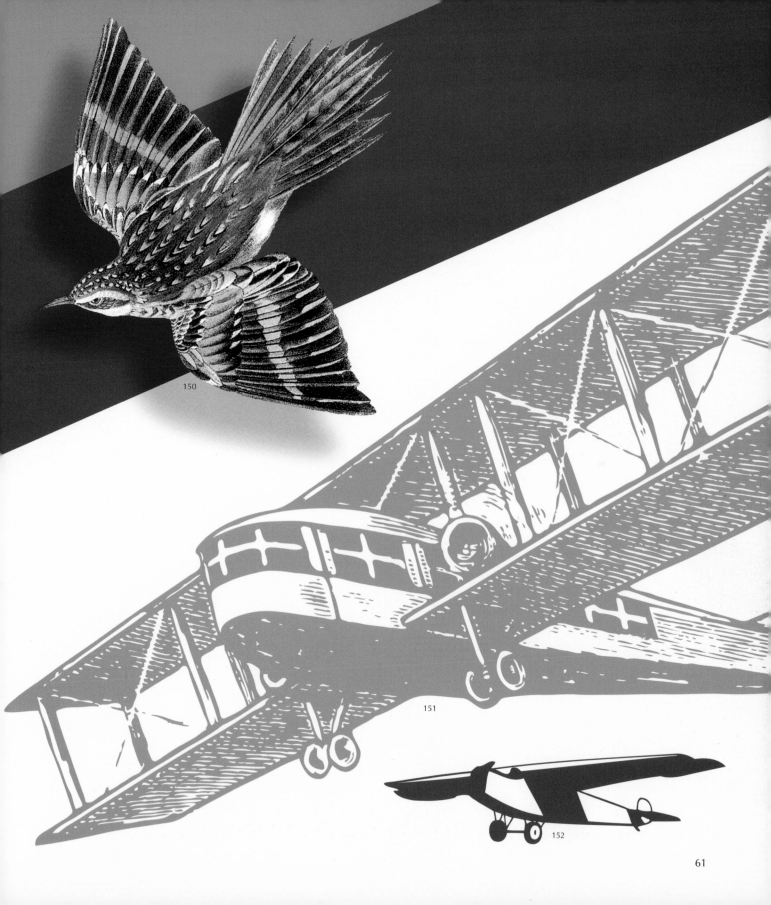

150

151

152

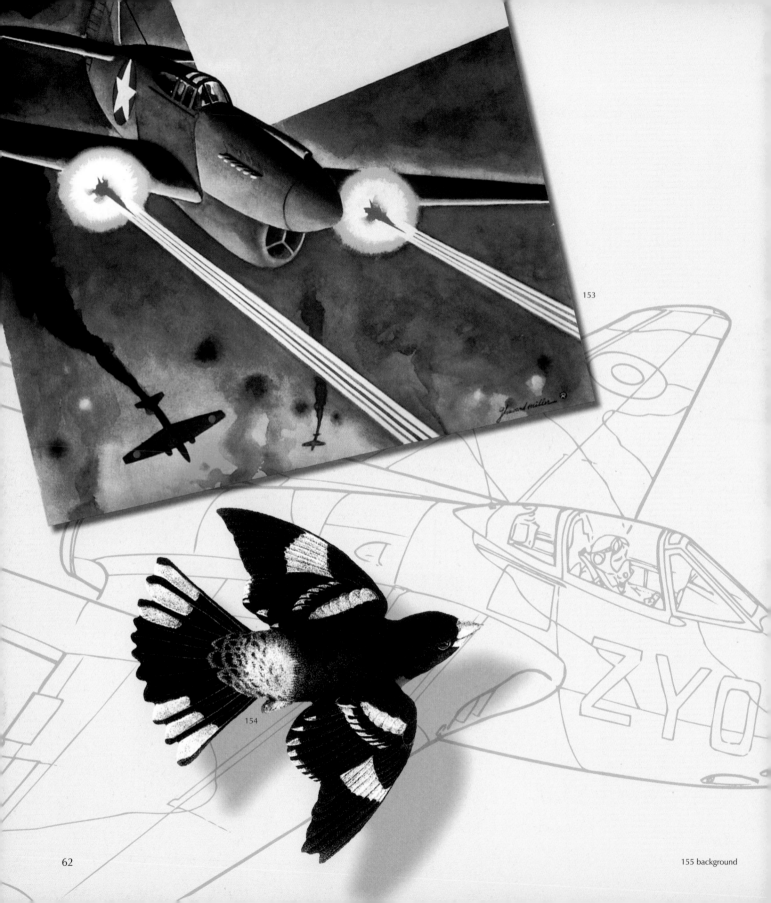

153

154

155 background

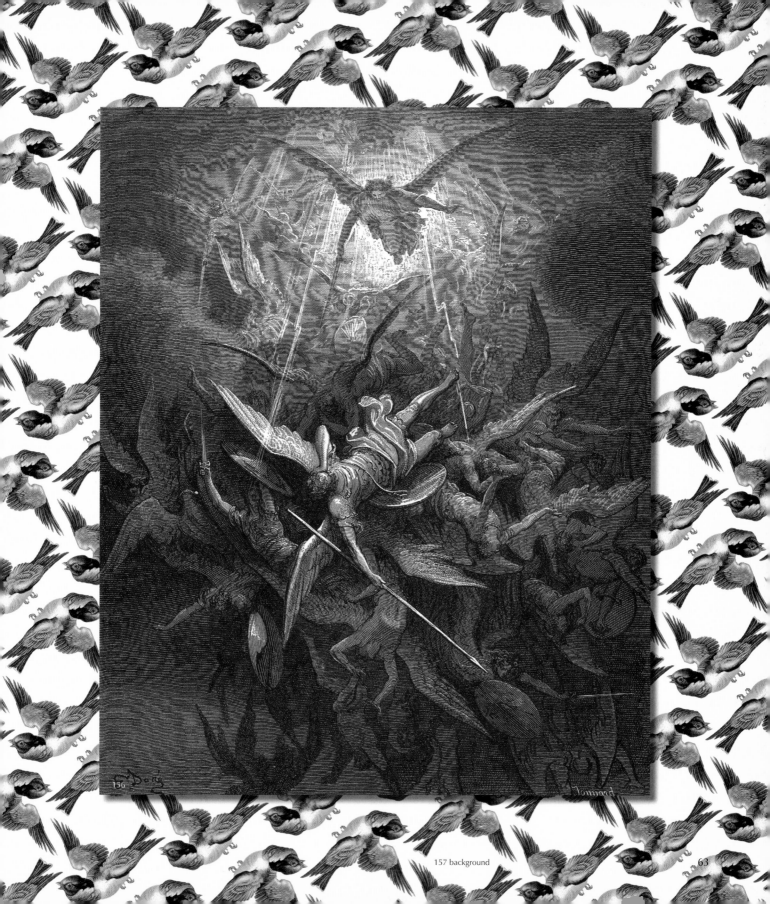

157 background

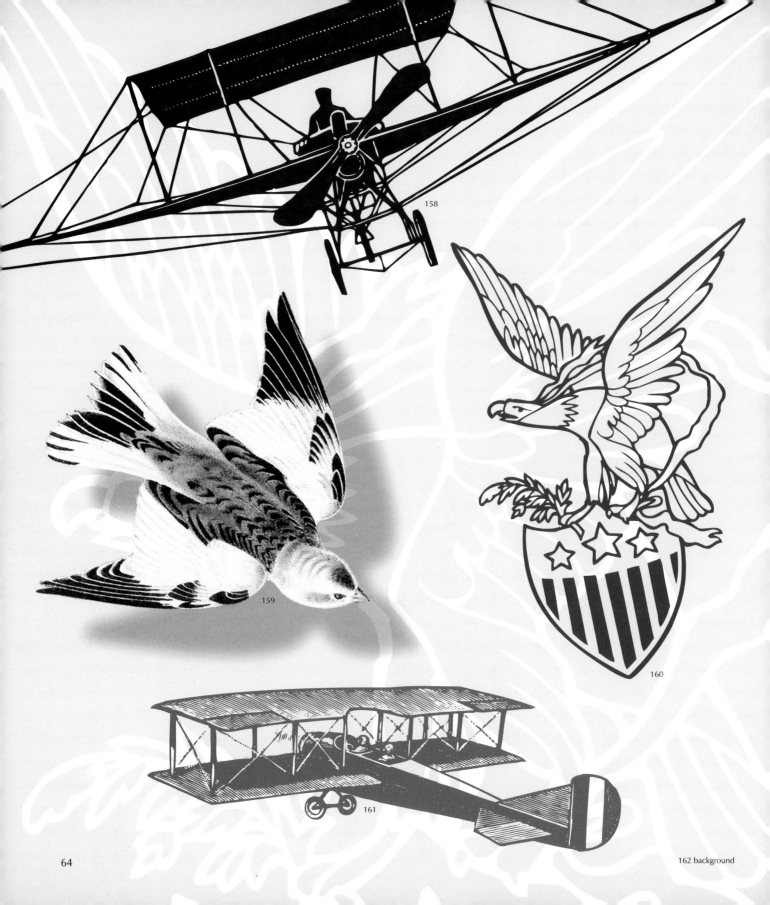

158

159

160

161

162 background

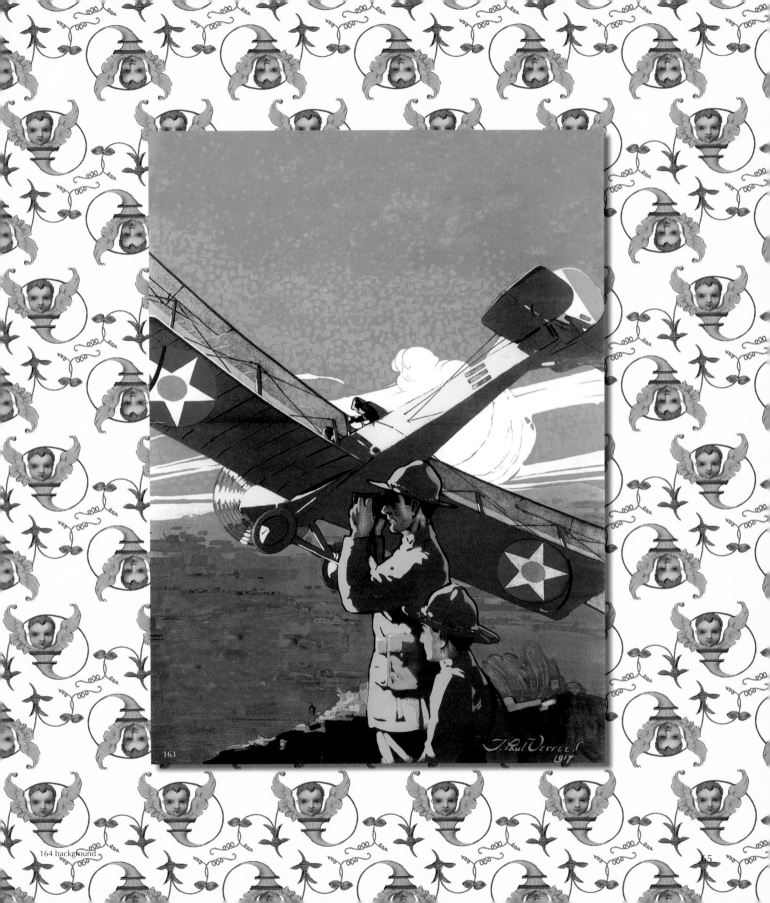

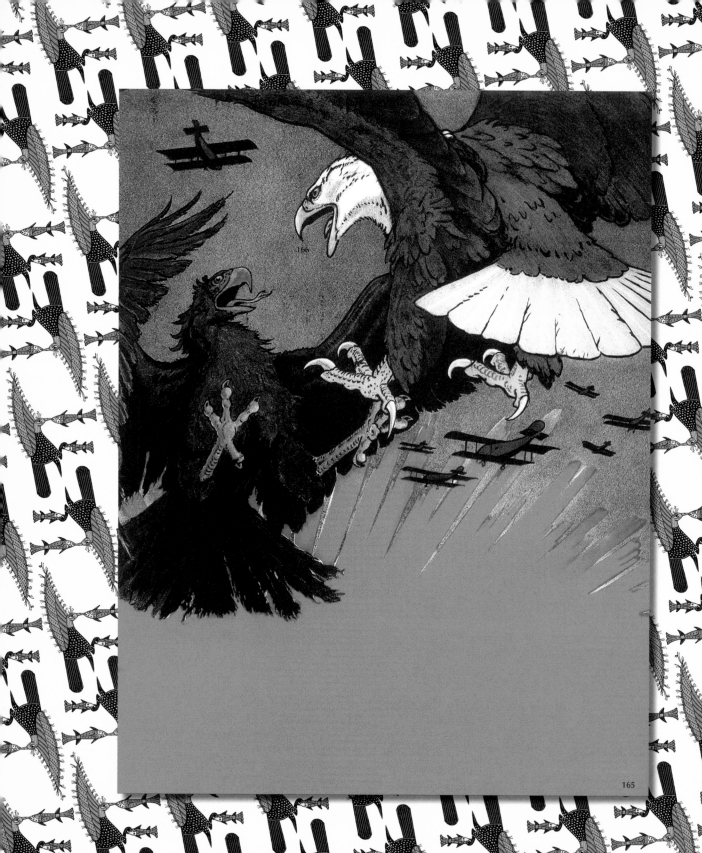

165

166

167

168

169

AI-III

171

172

173

174

175 background

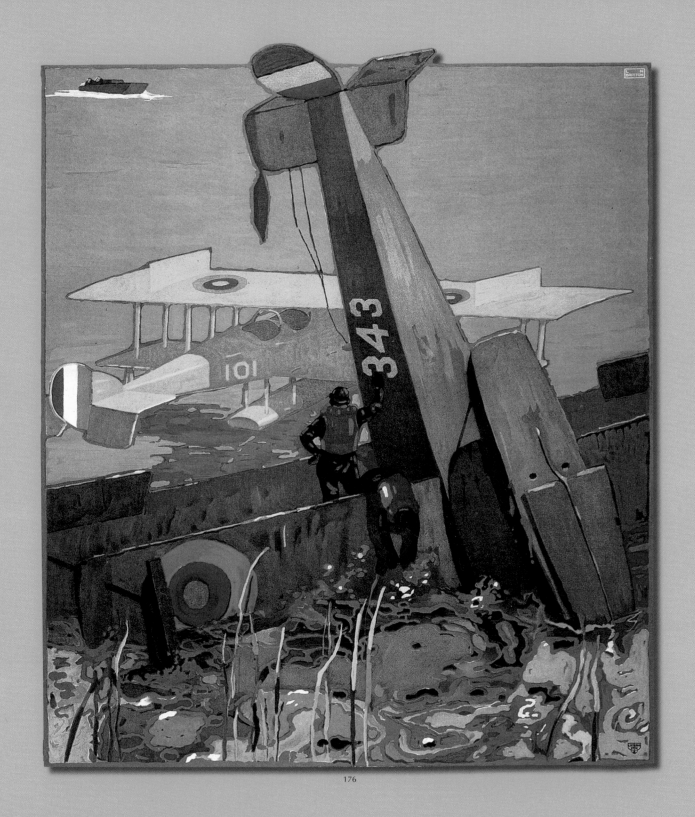

176

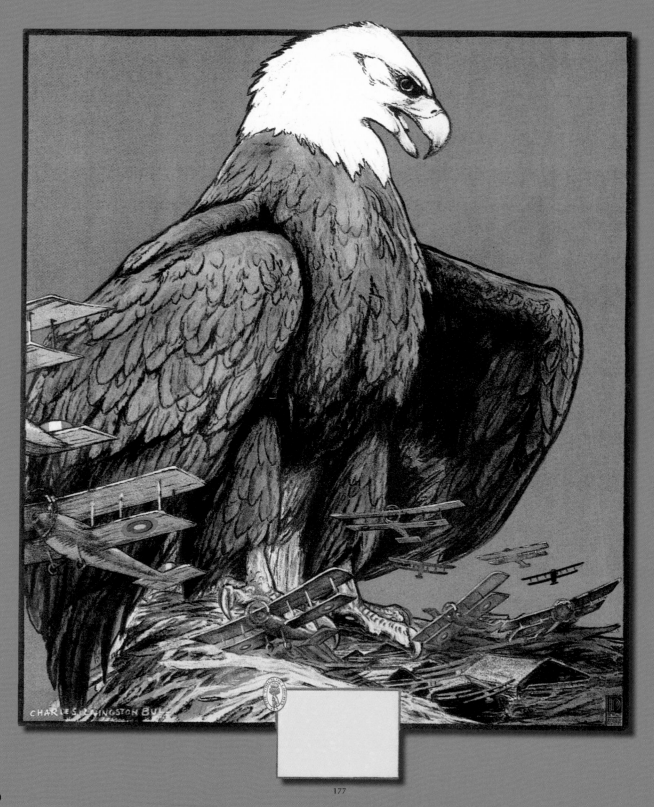

CHARLES LIVINGSTON BULL

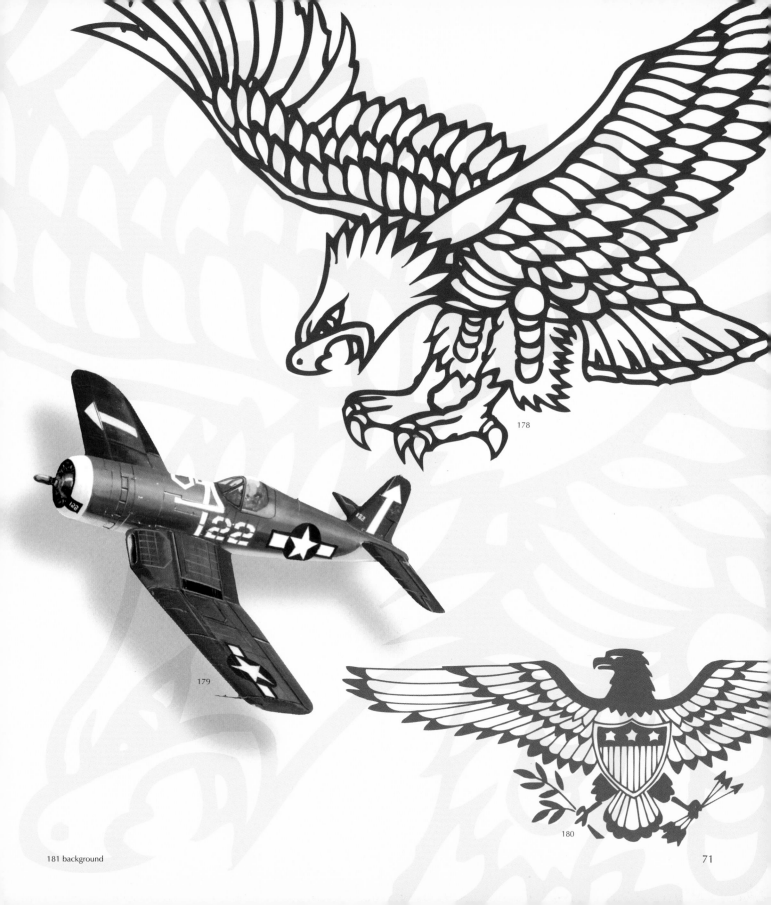

178

179

180

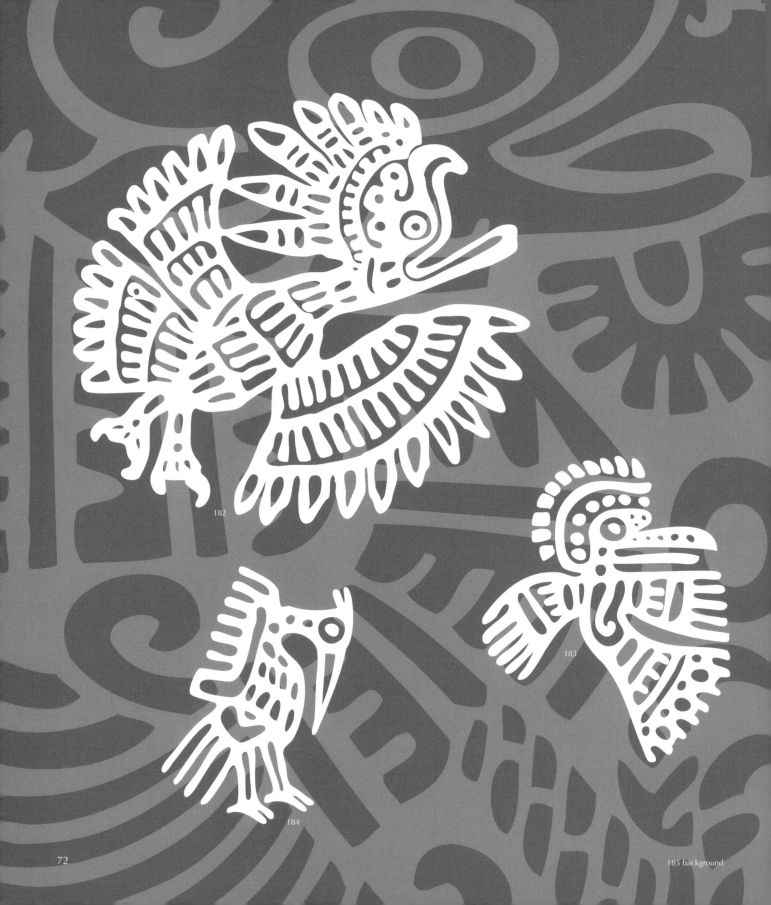

182

183

184

185 background

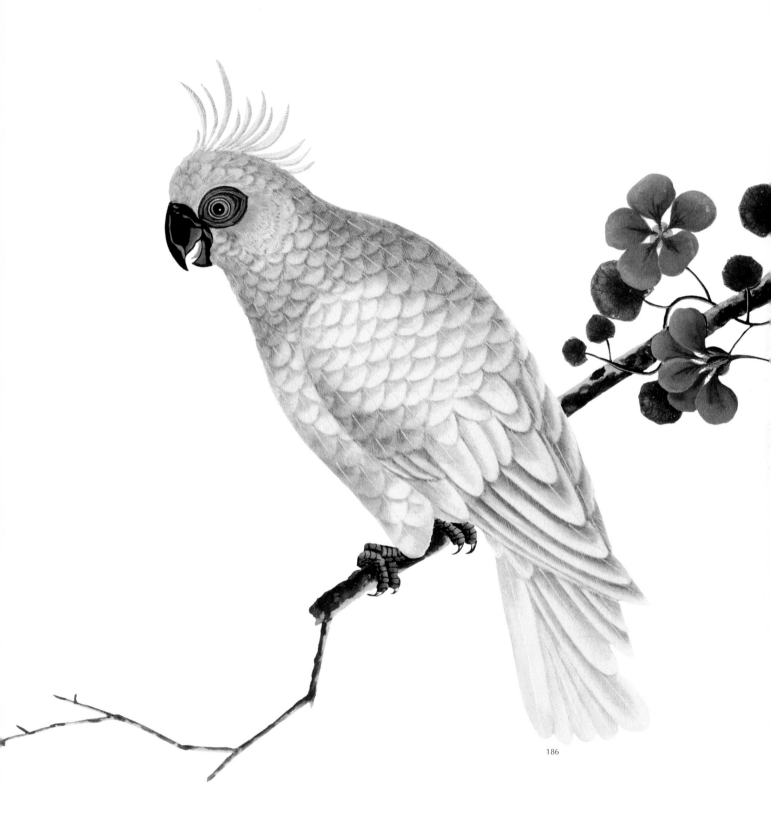

186

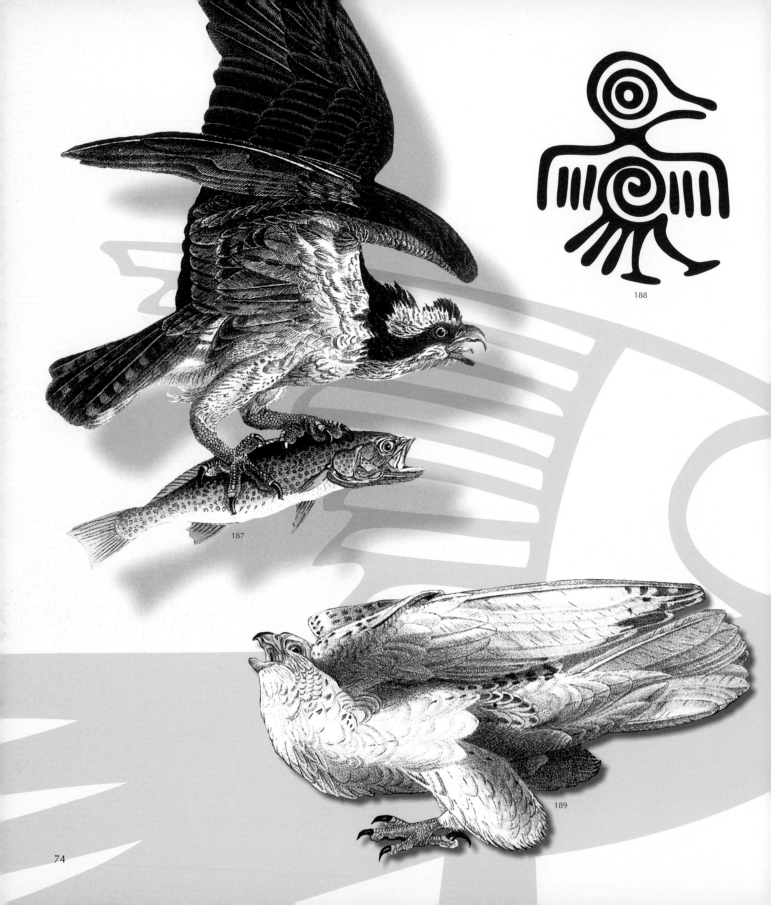

187

188

189

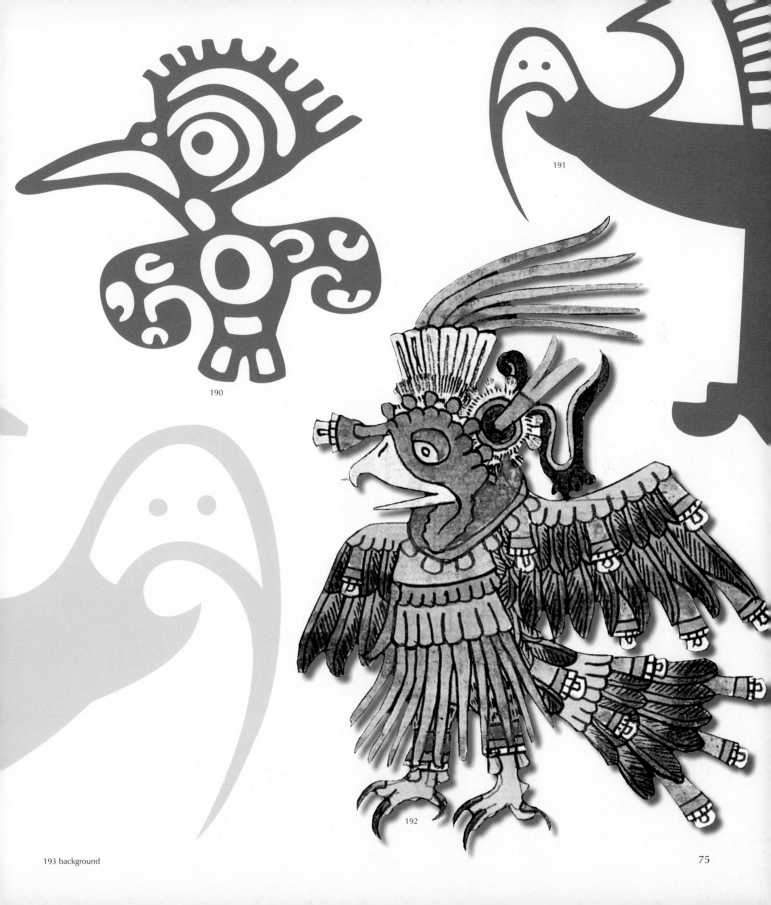

190

191

192

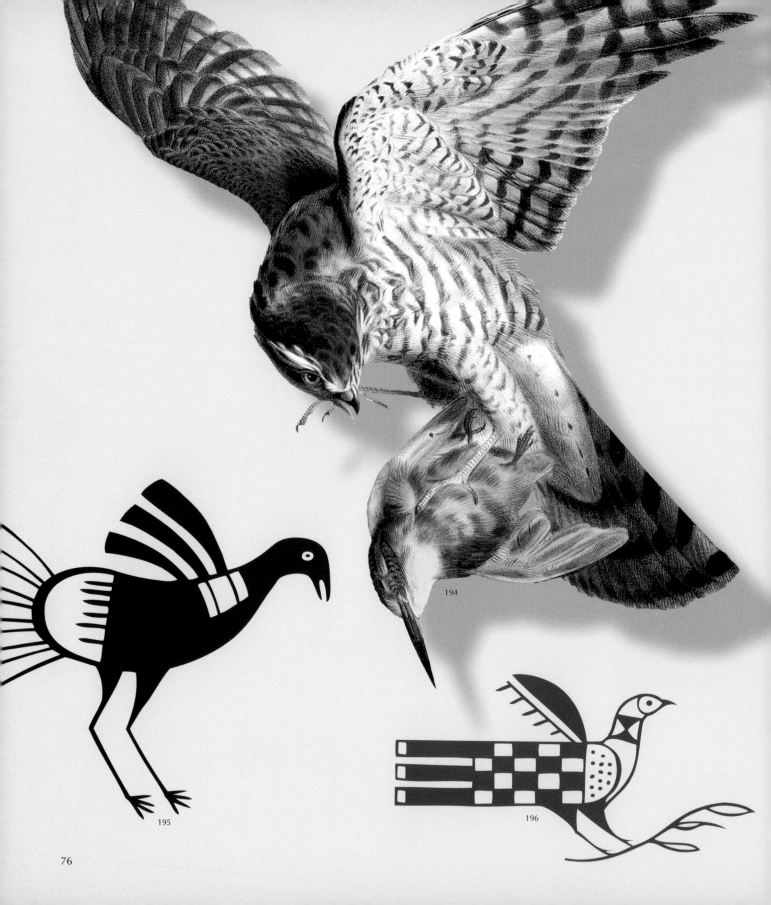

194

195

196

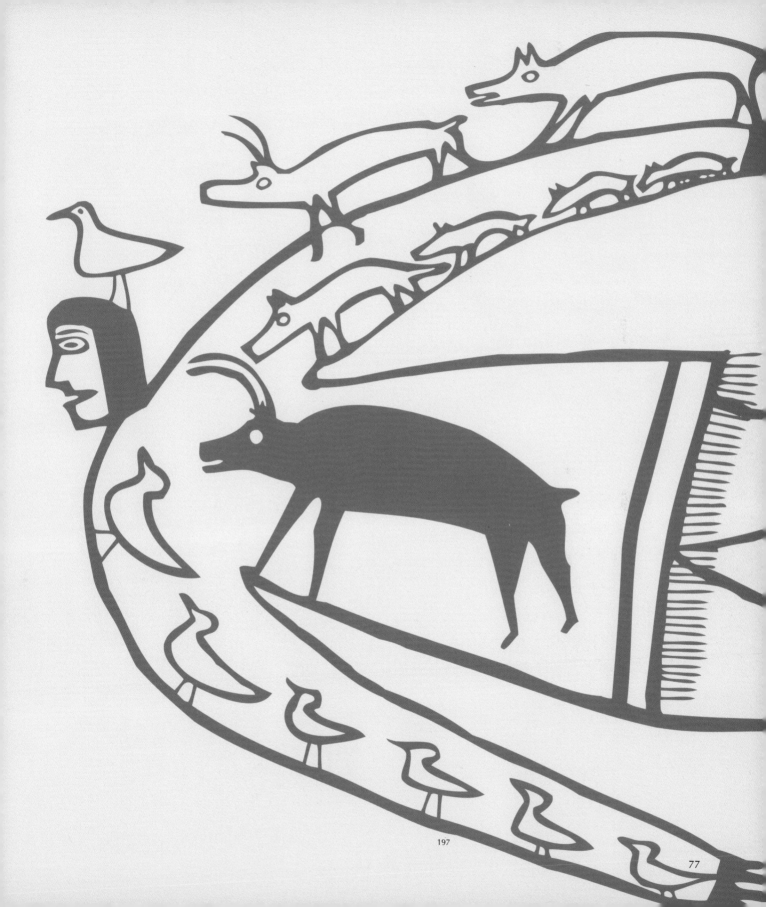

197

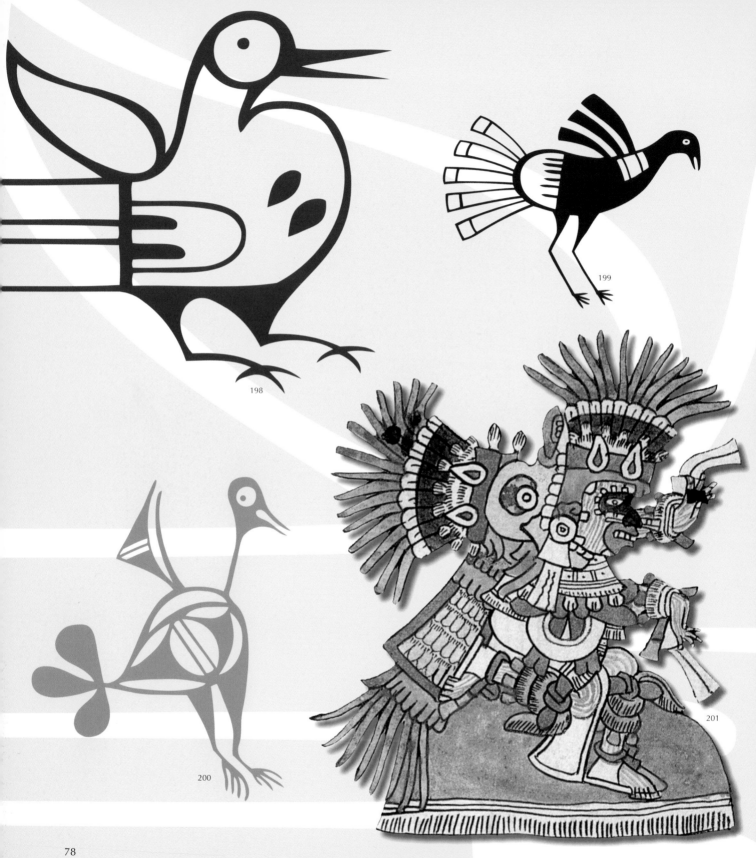

198

199

200

201

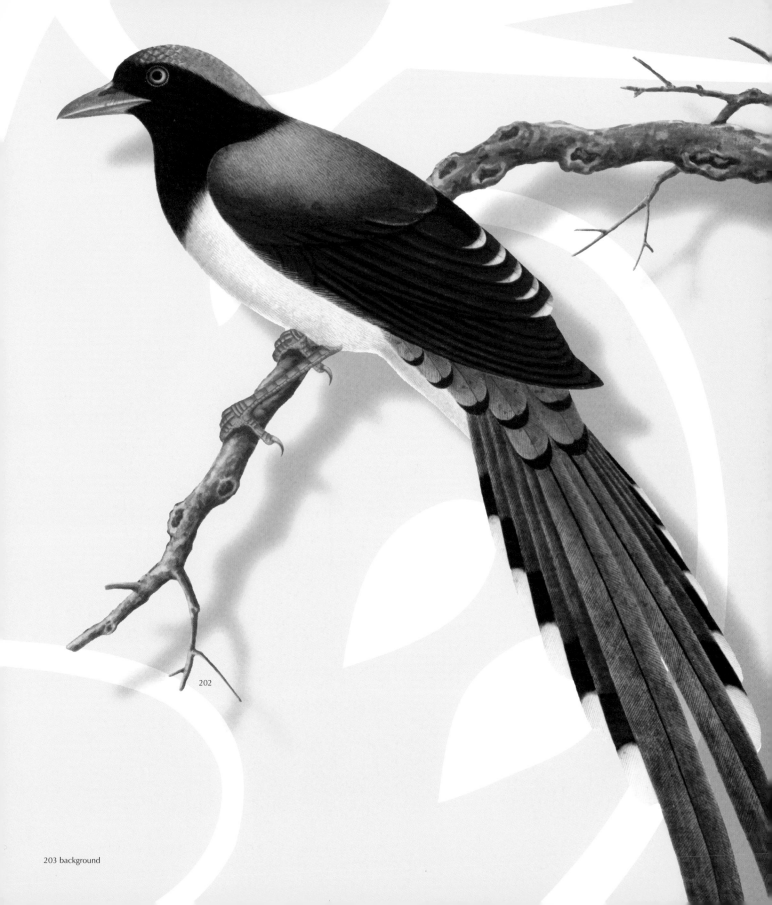

202

203 background

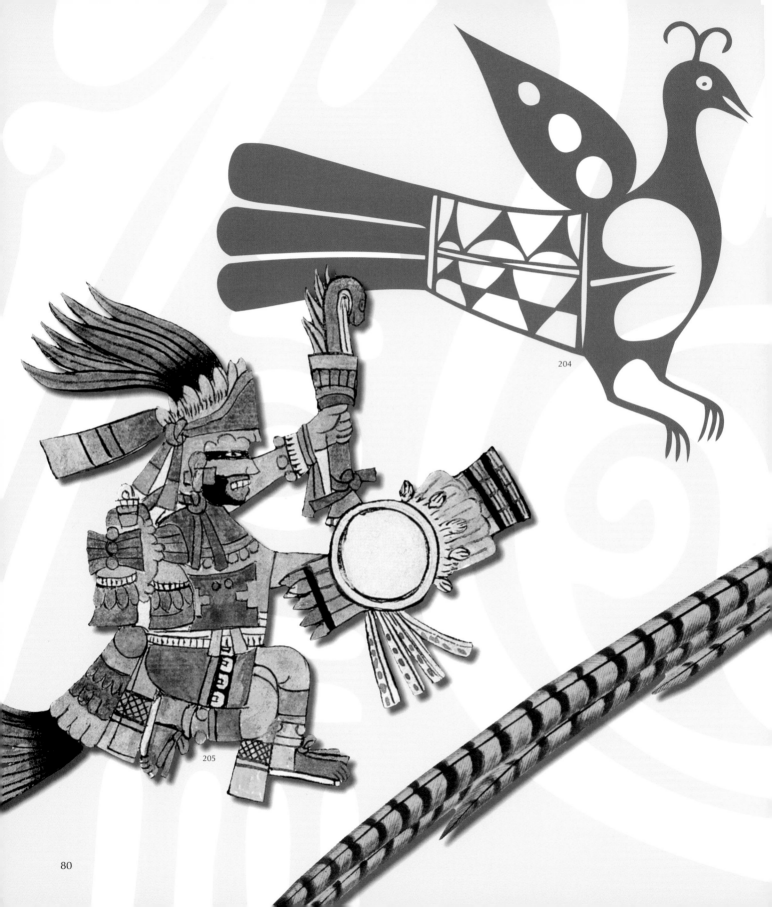

204

205

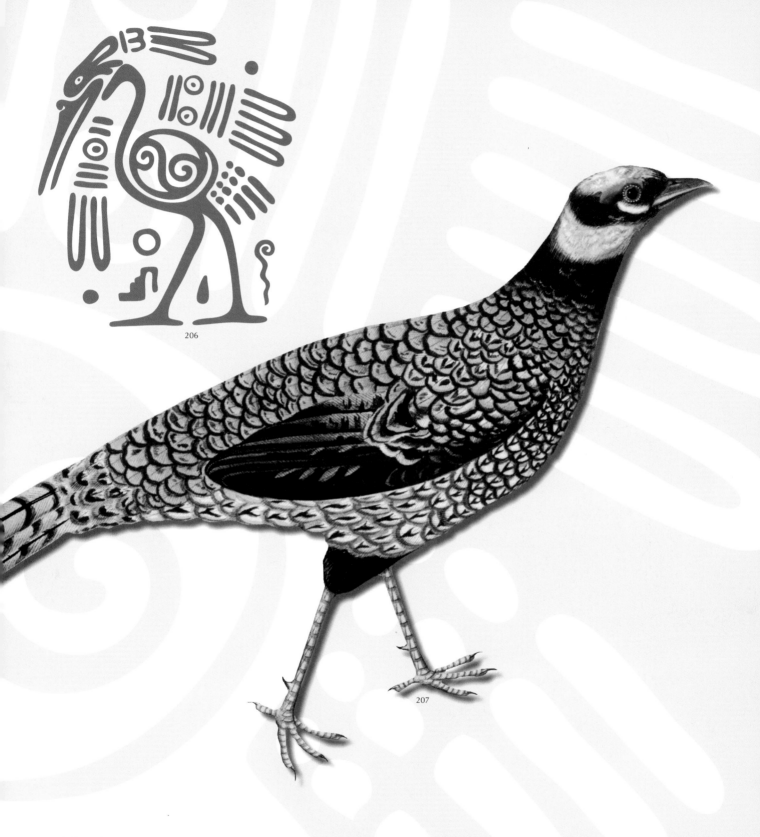

206

207

208 background

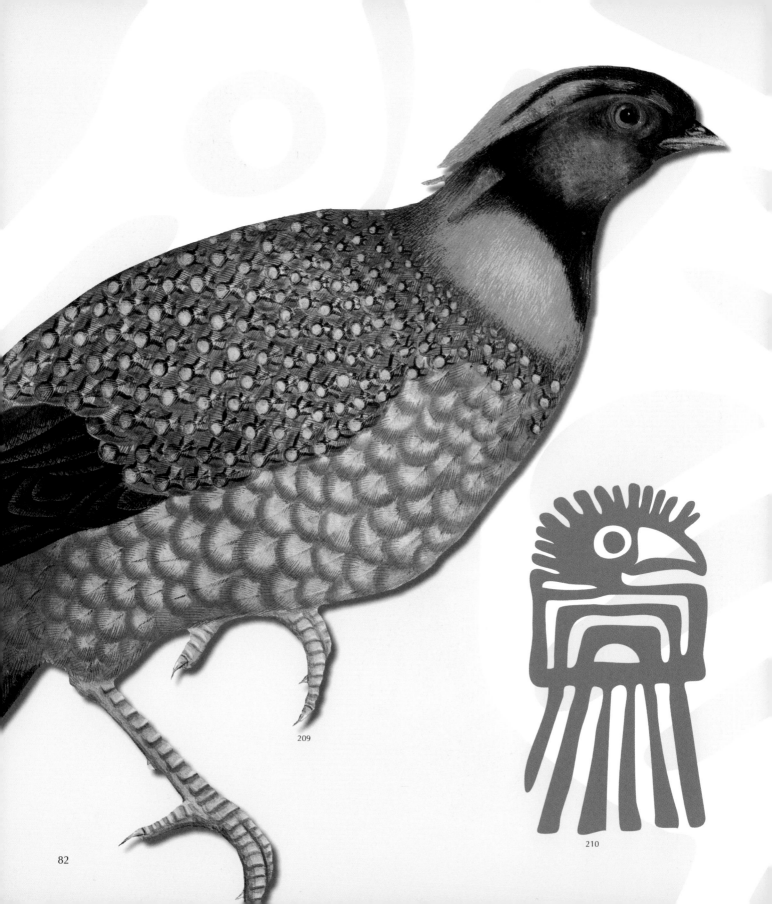

209

210

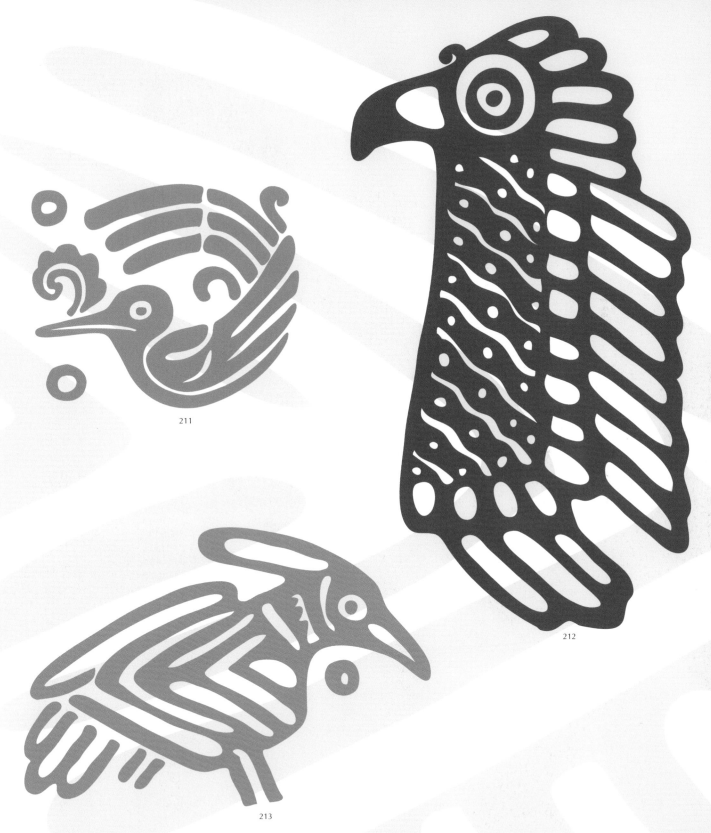

211

212

213

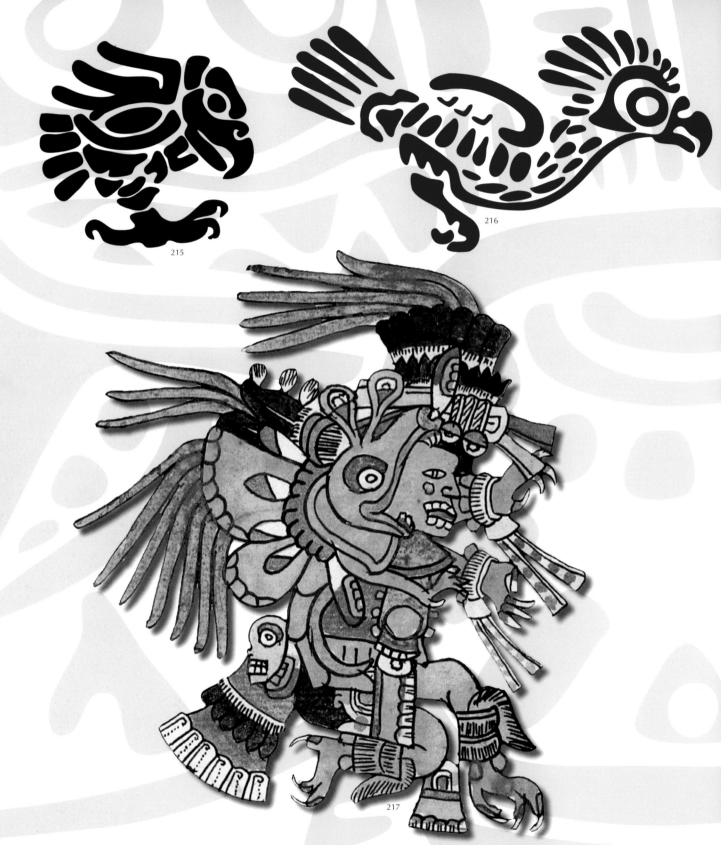

215

216

217

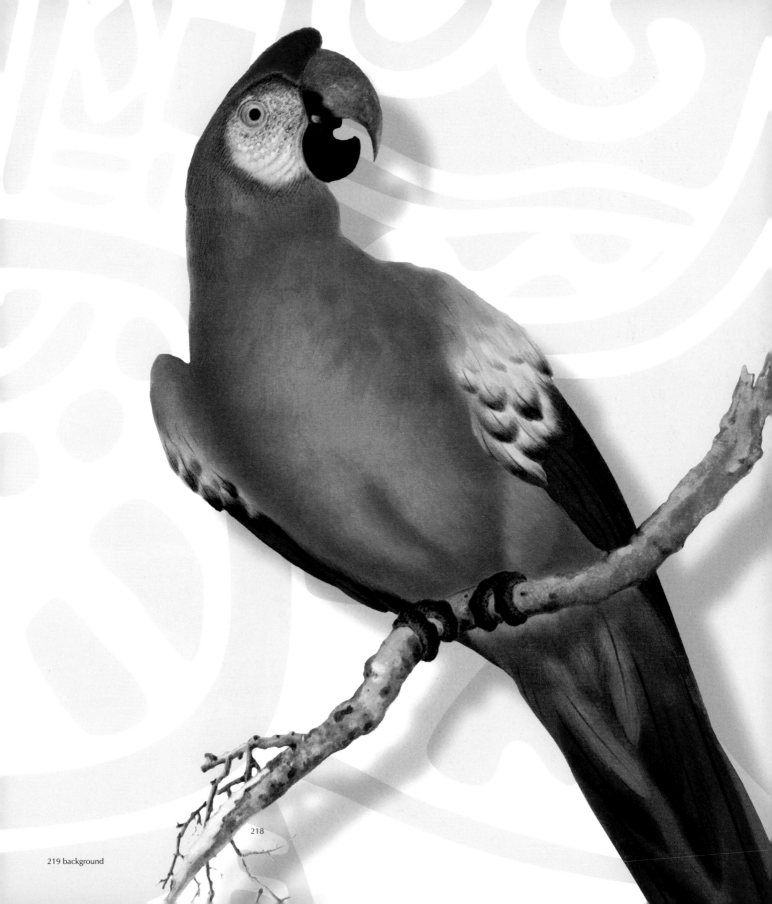

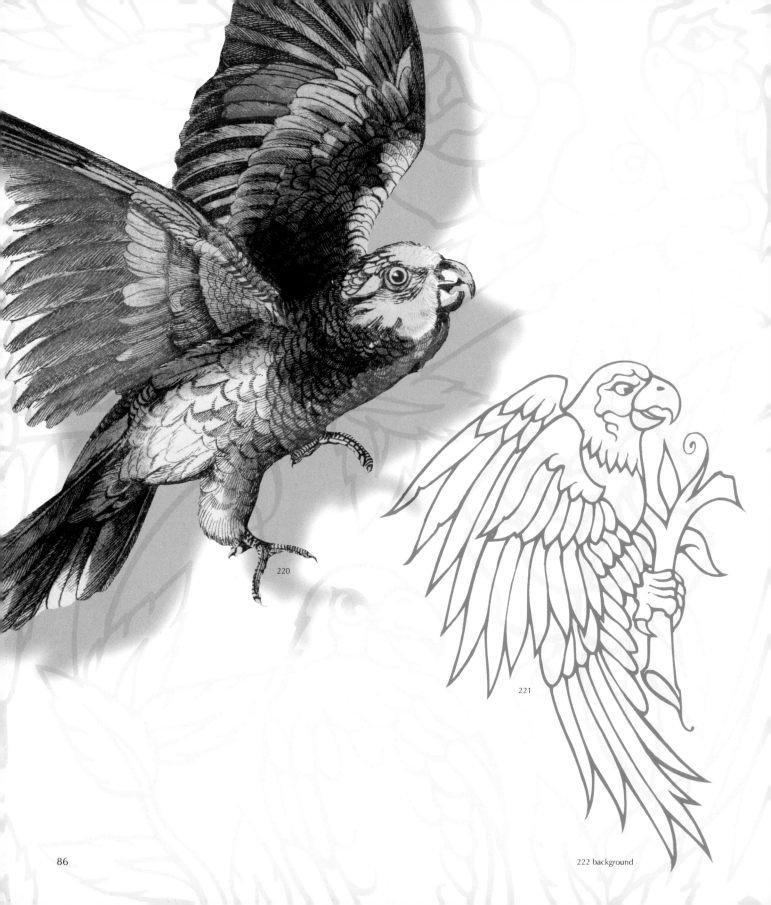

220

221

222 background

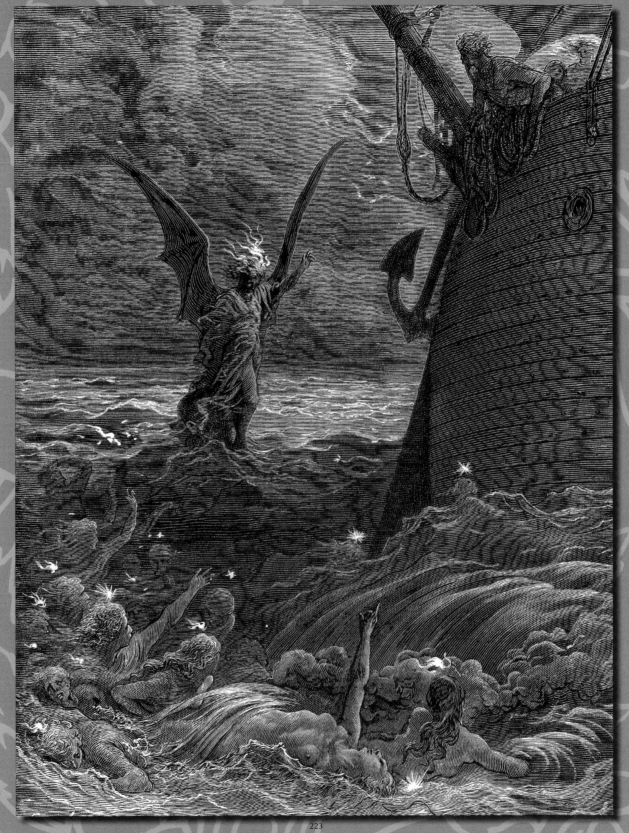

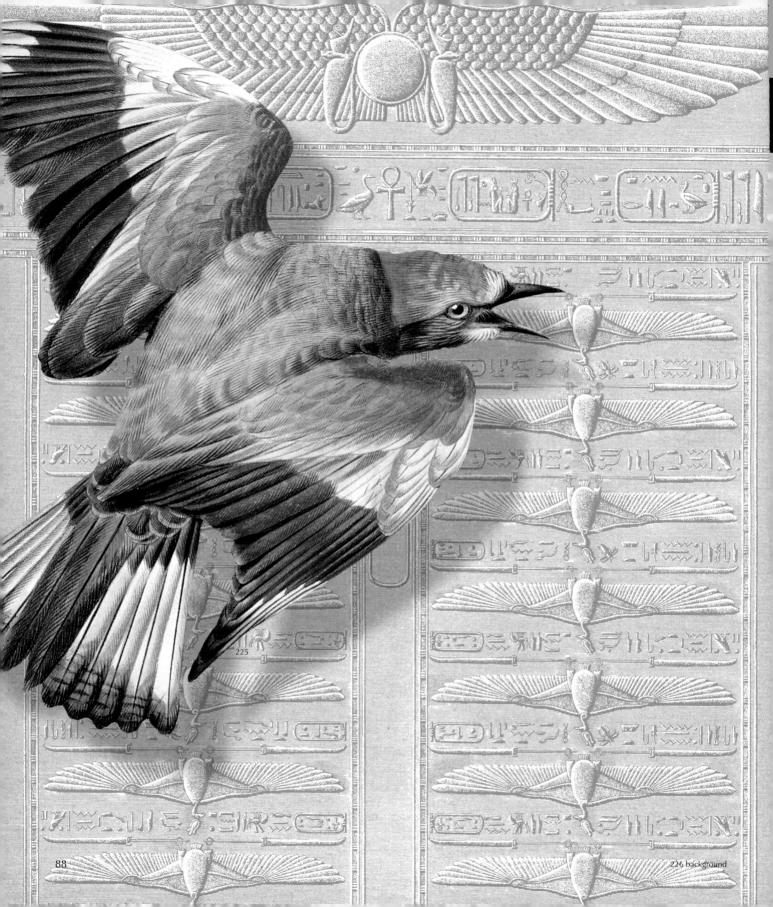

226 background

225

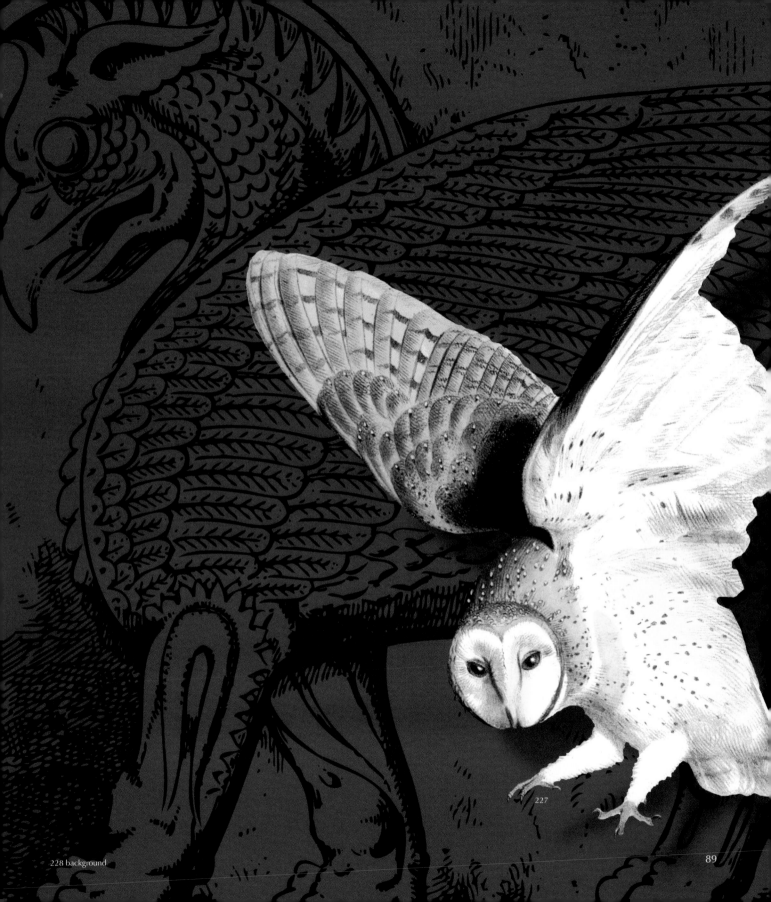

227

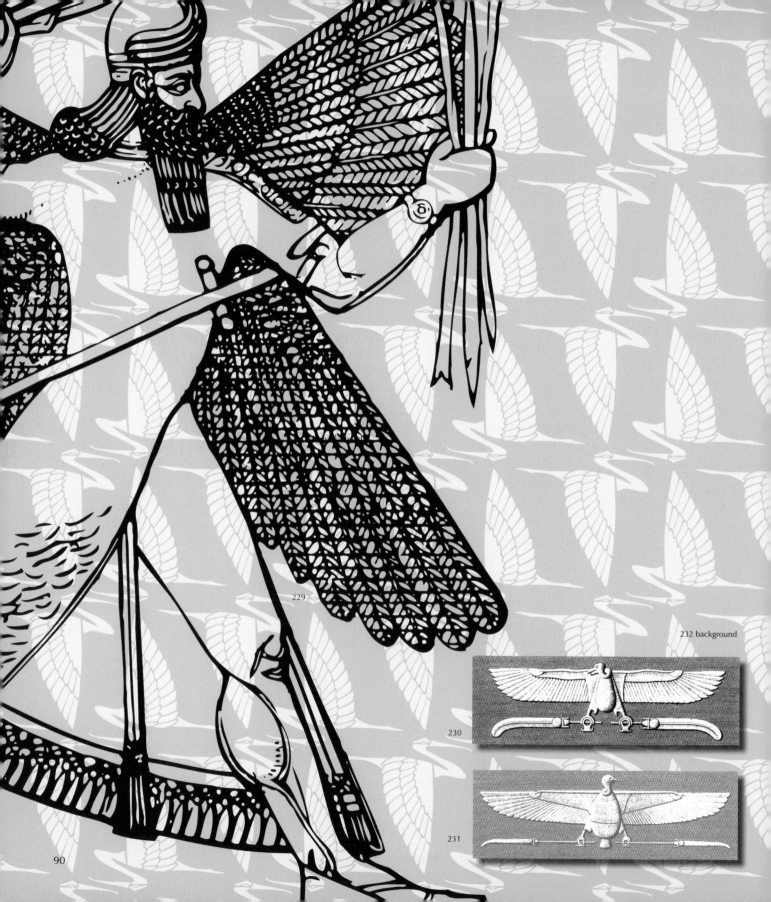

229

232 background

230

231

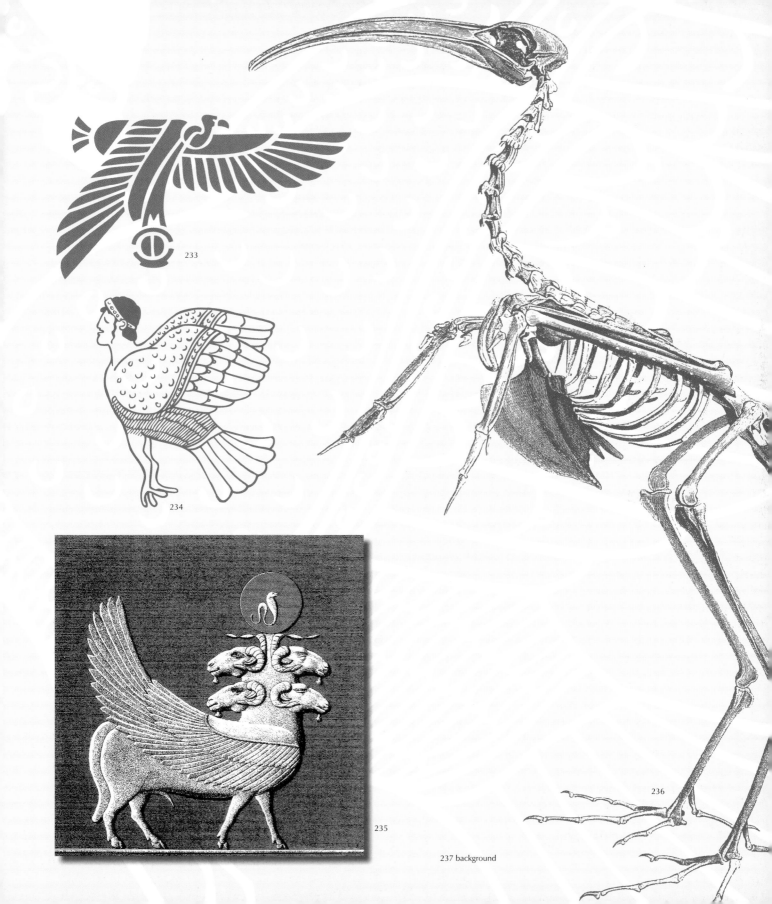

233

234

235

237 background

236

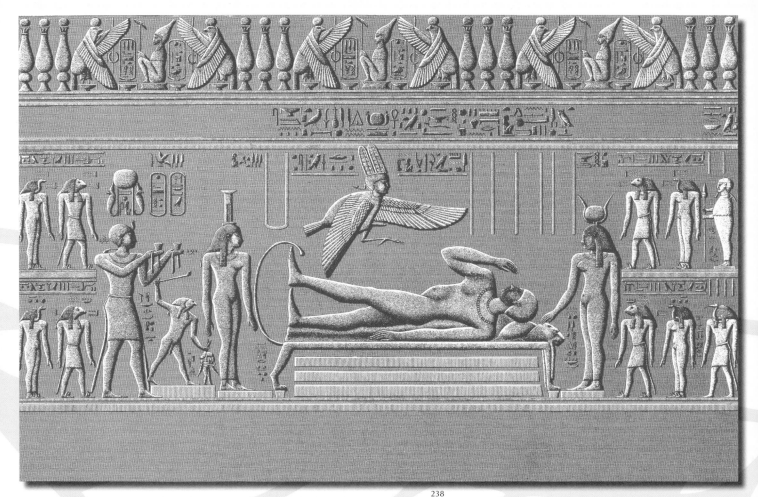

238

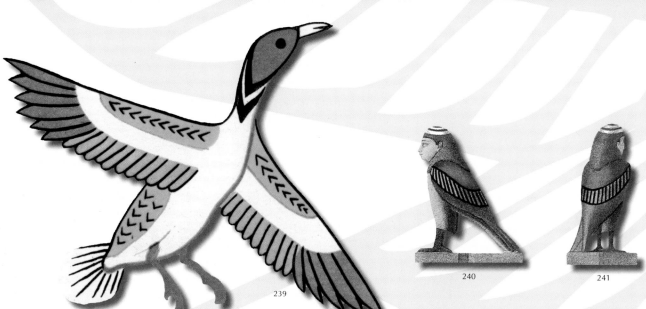

239

240

241

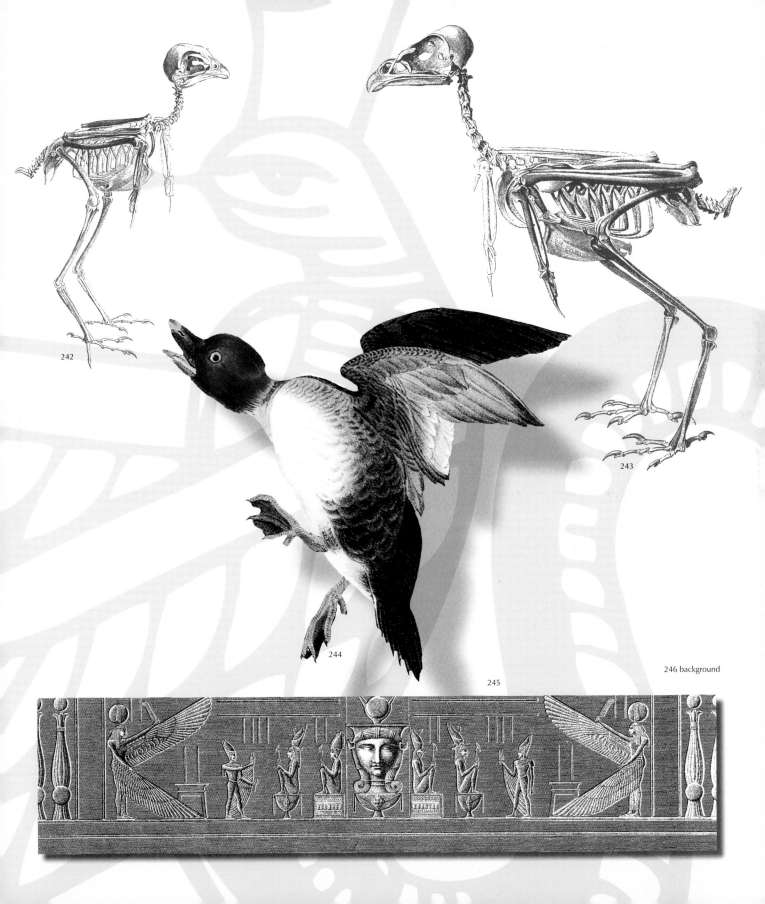

242

243

244

245

246 background

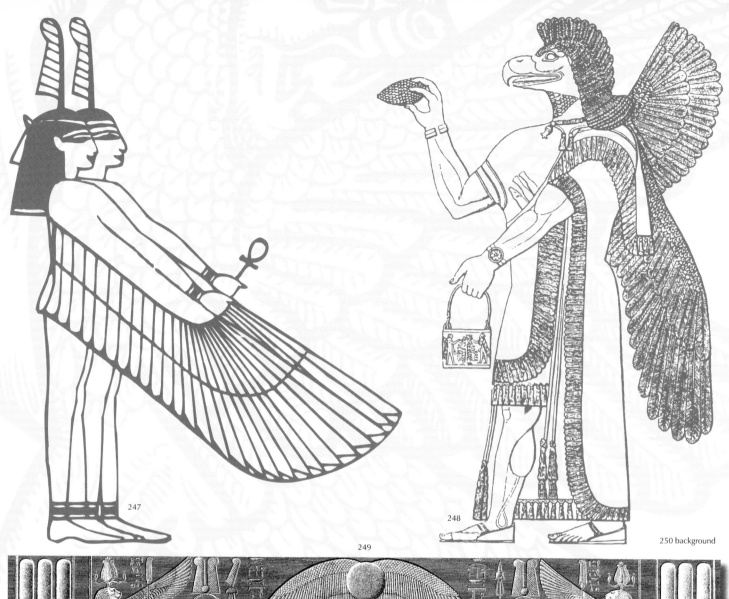

247

248

249

250 background

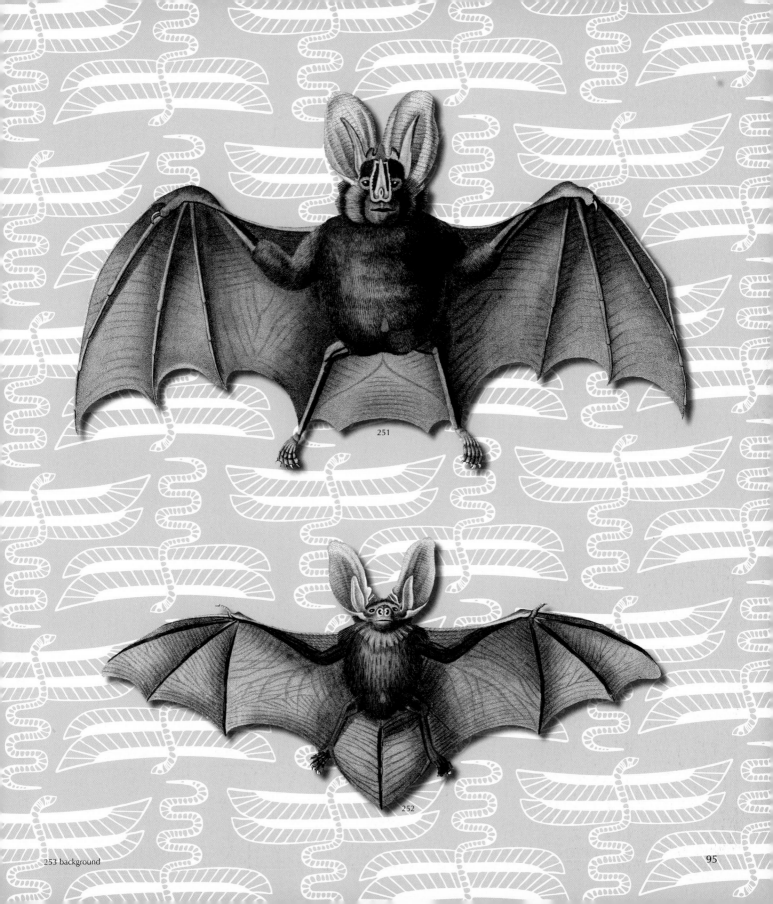

251

252

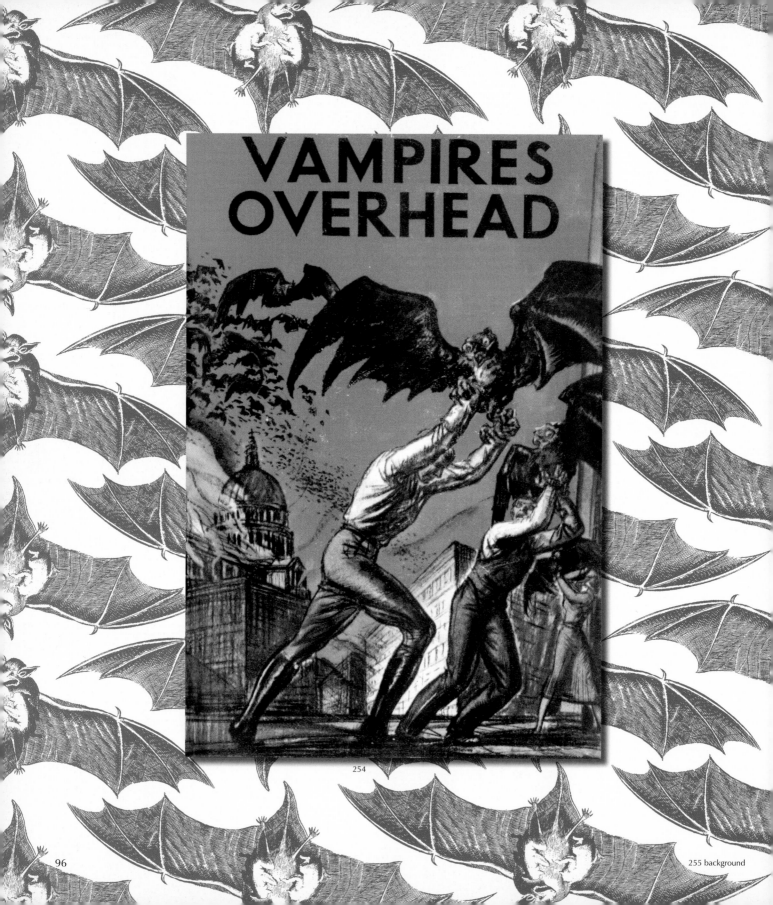

VAMPIRES OVERHEAD

254

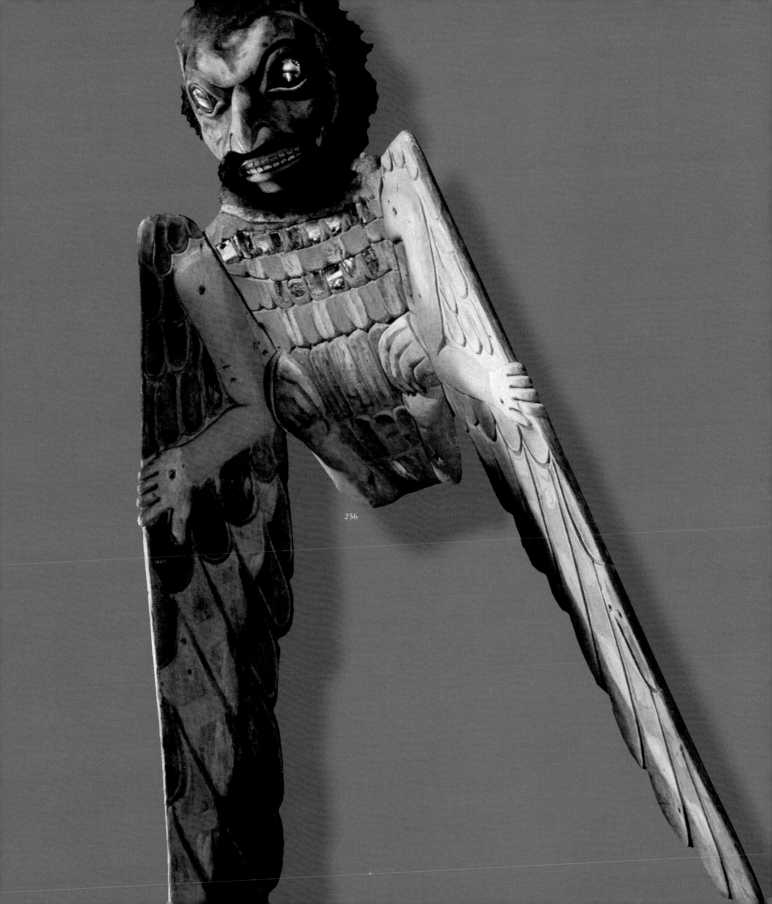

256

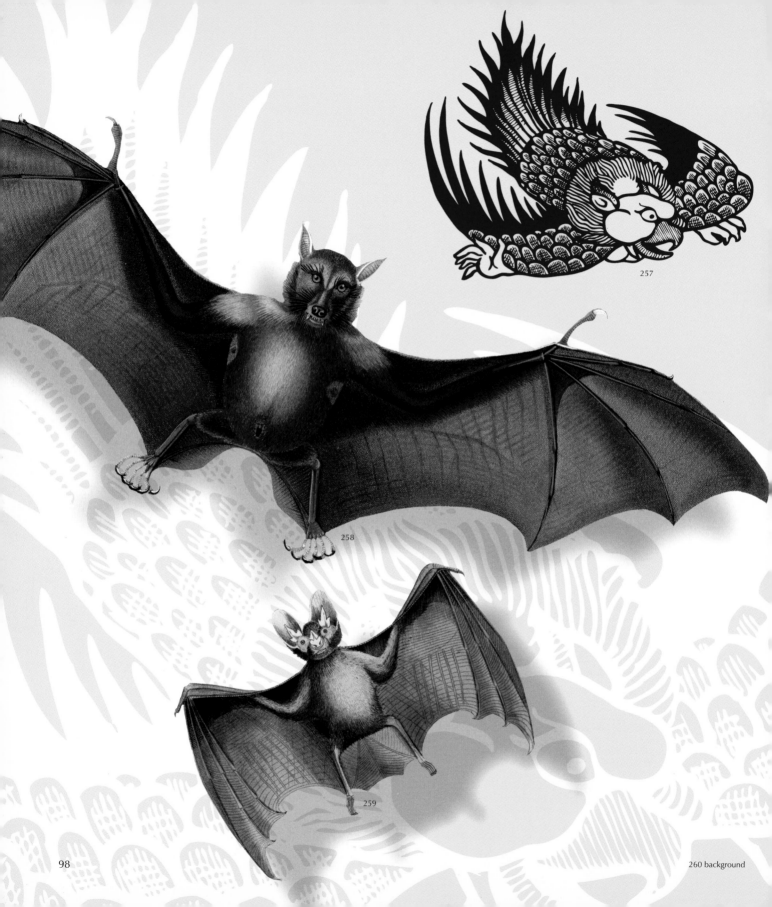

257

258

259

260 background

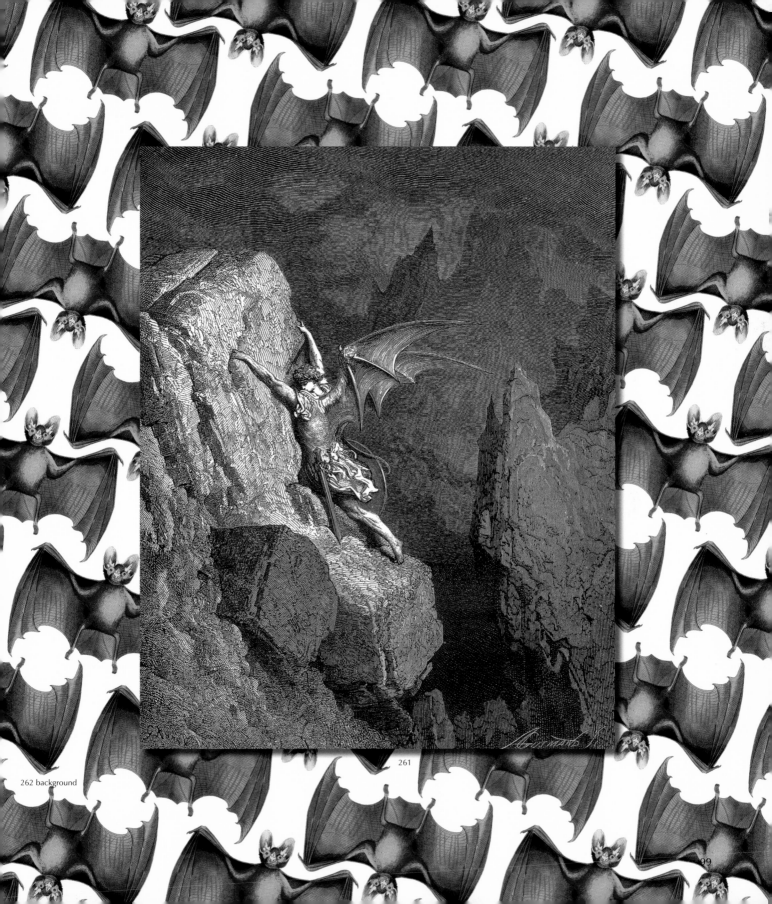

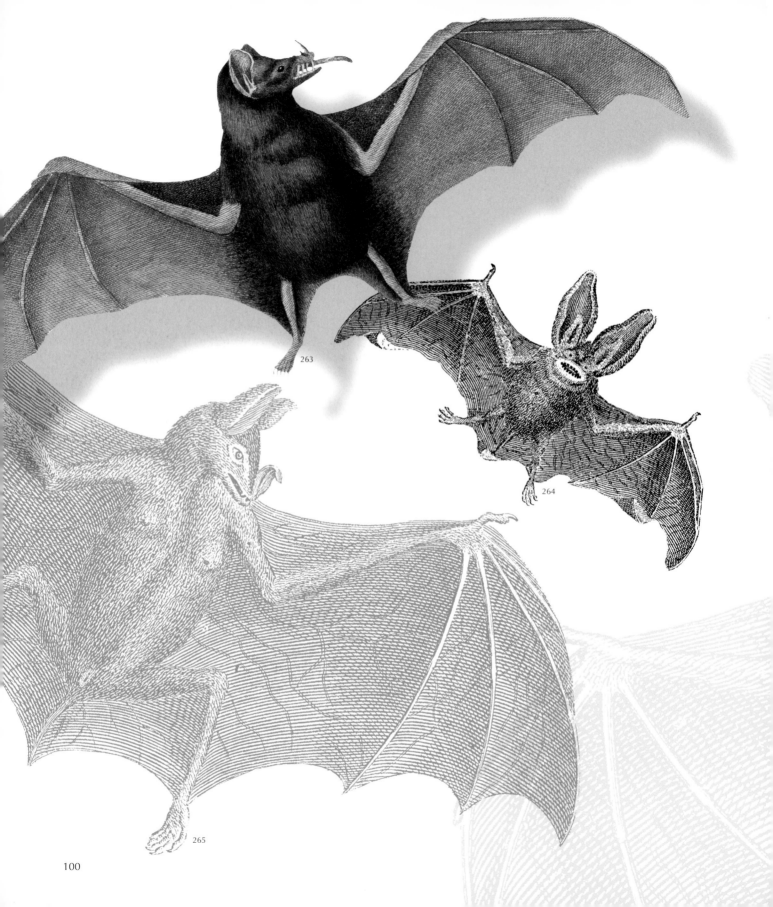

263

264

265

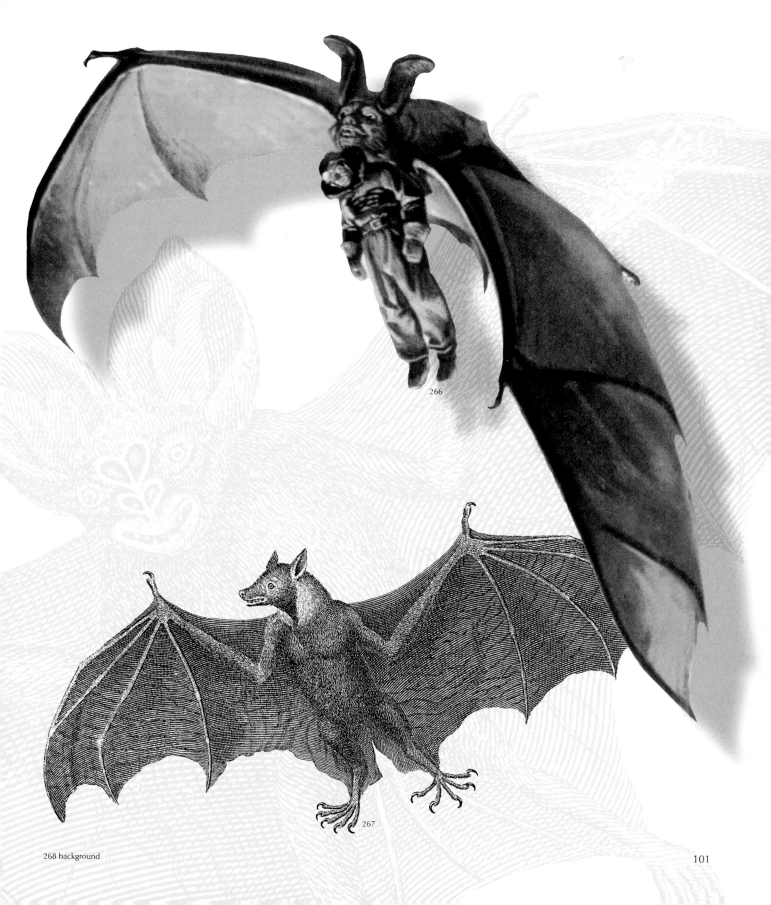

266

267

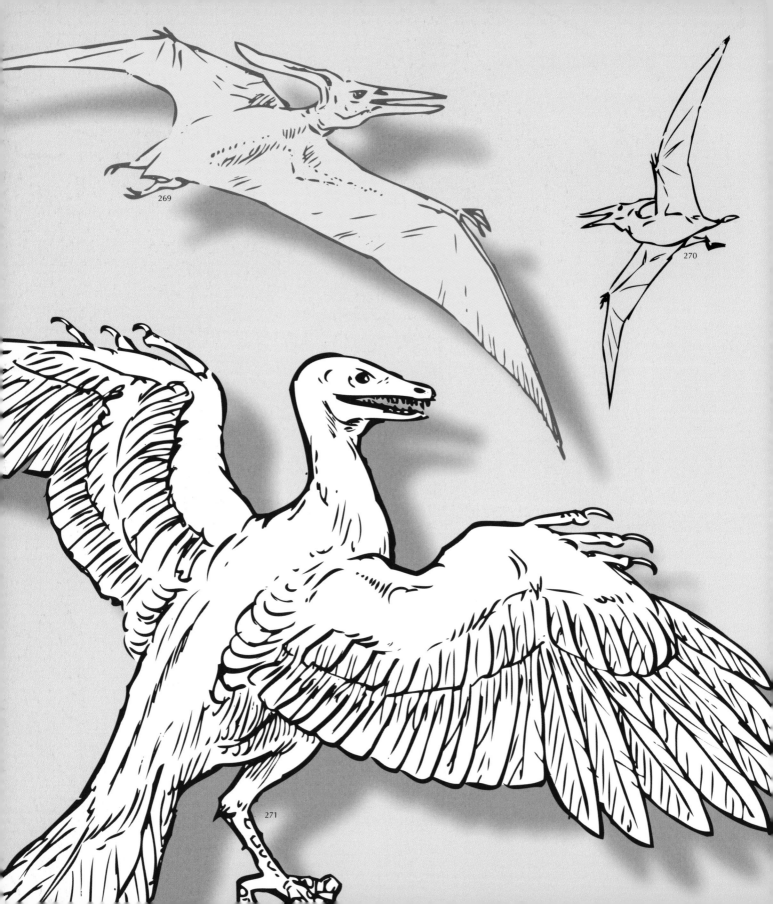

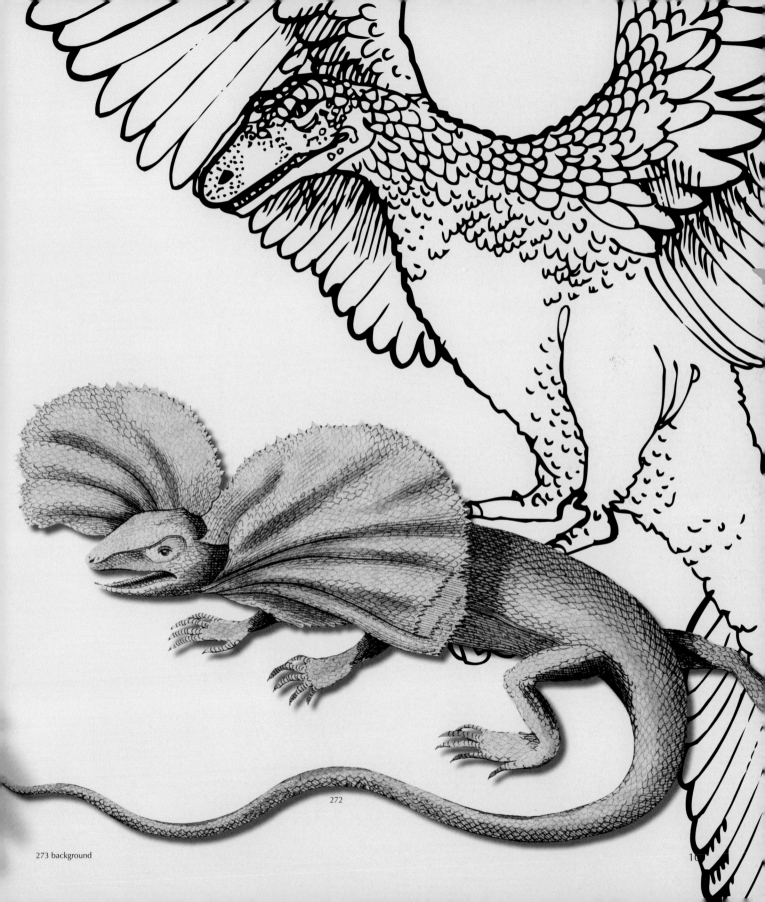

272

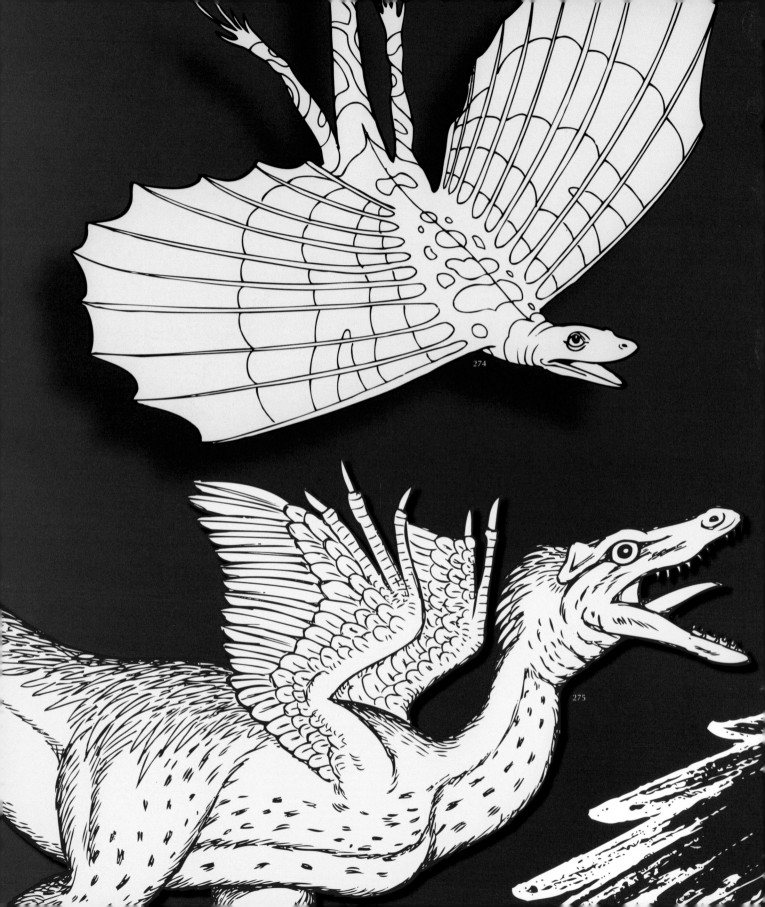

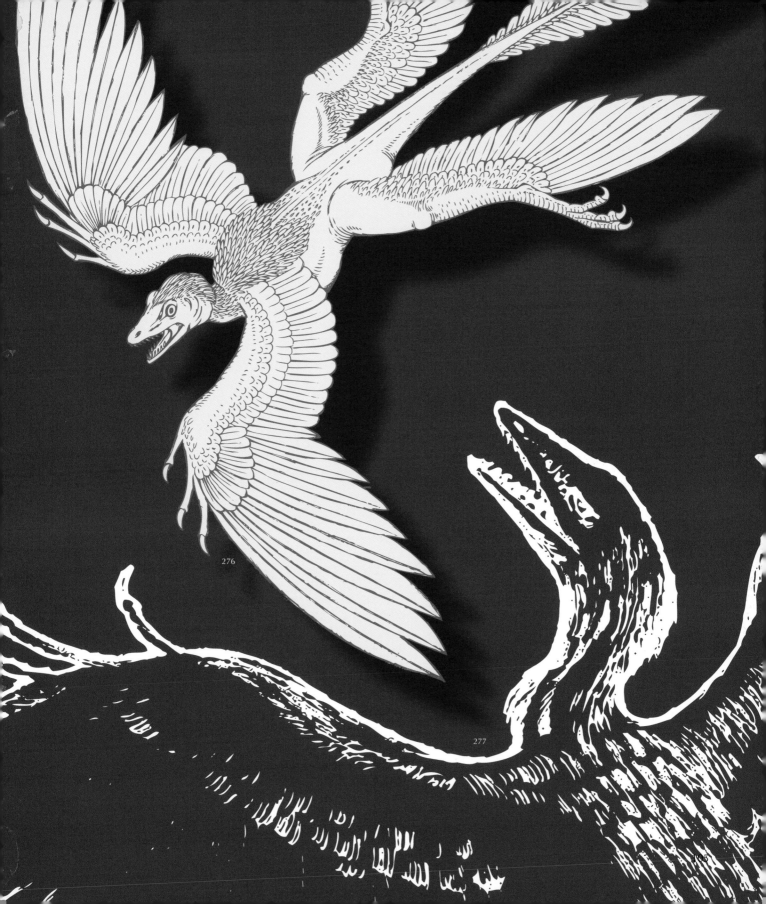

276

277

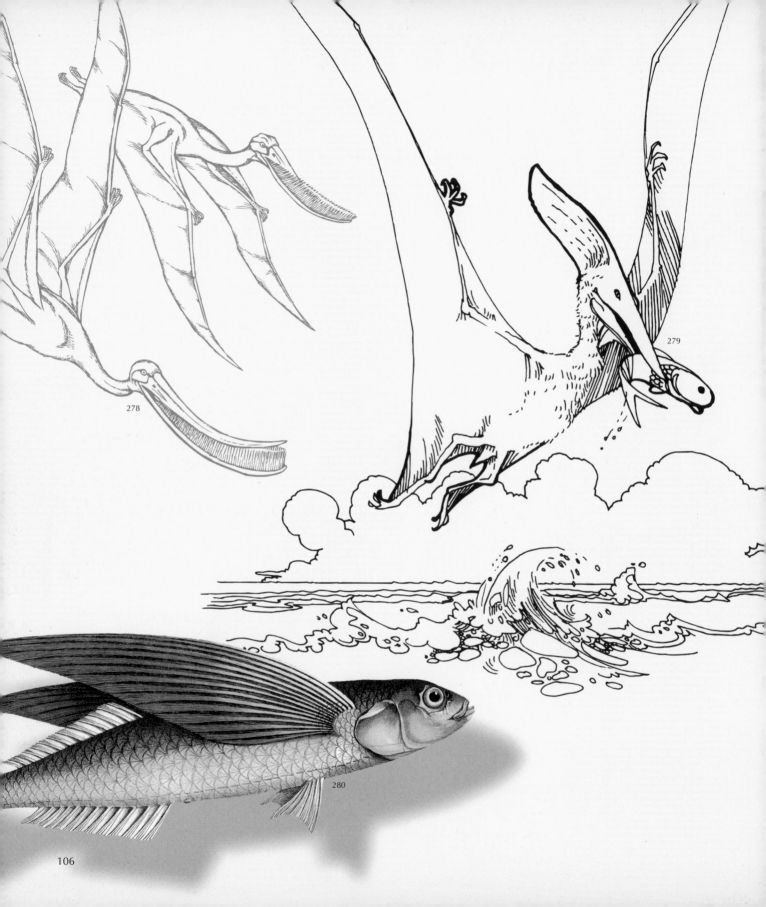

278

279

280

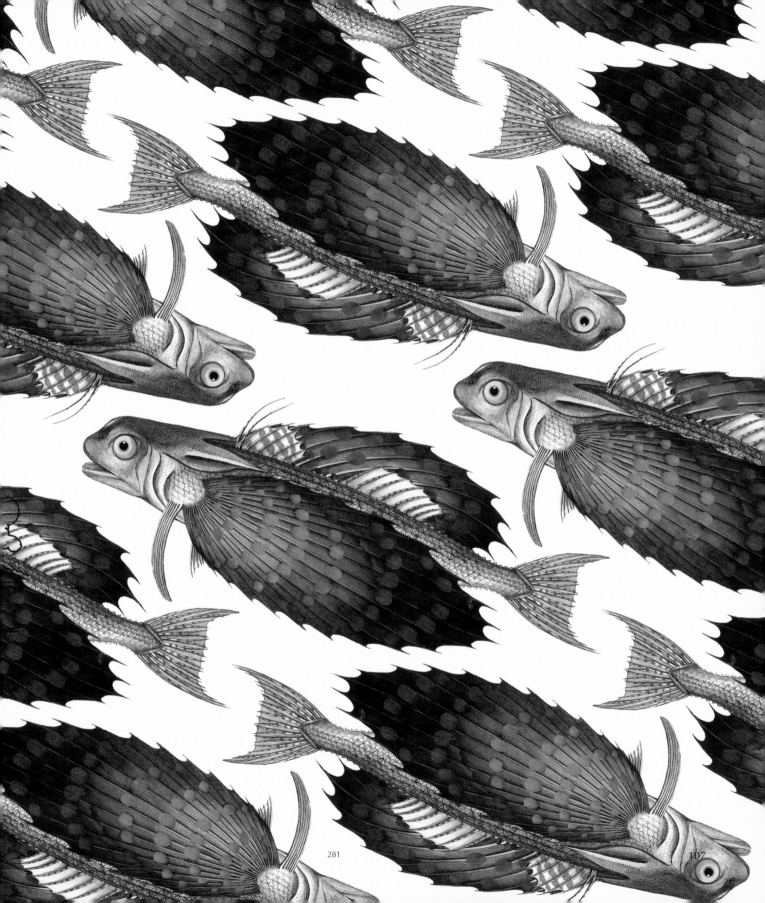

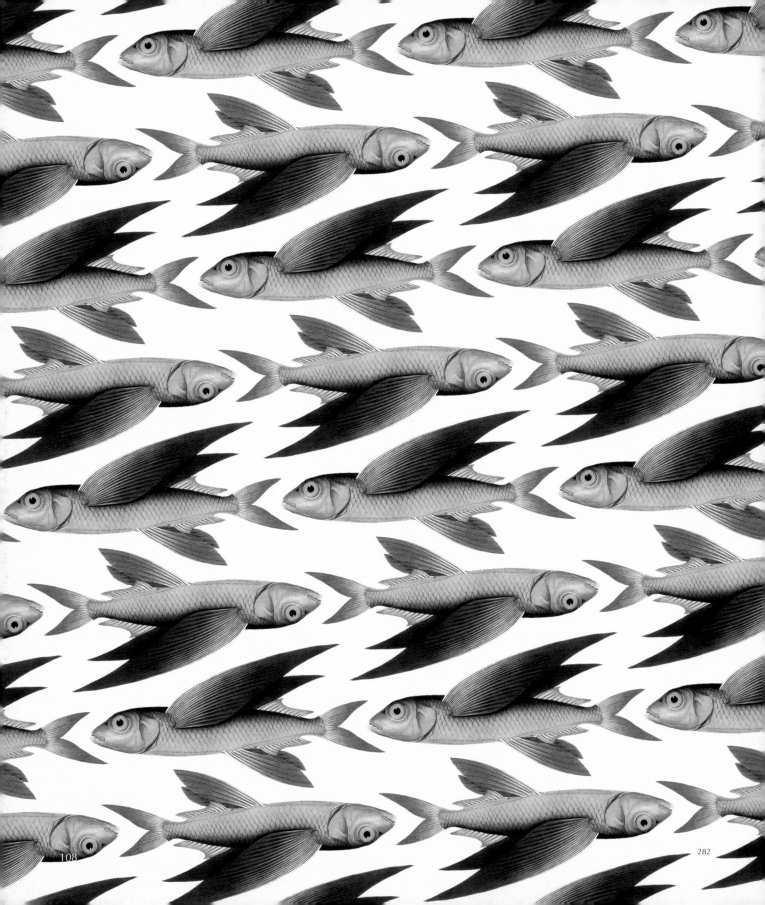

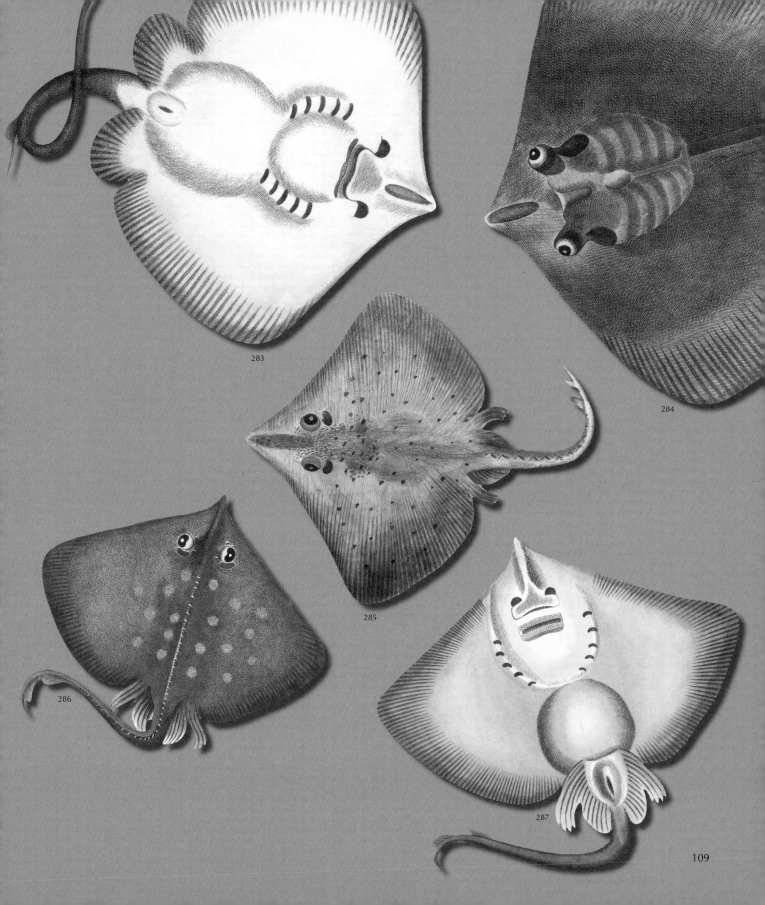

283

284

285

286

287

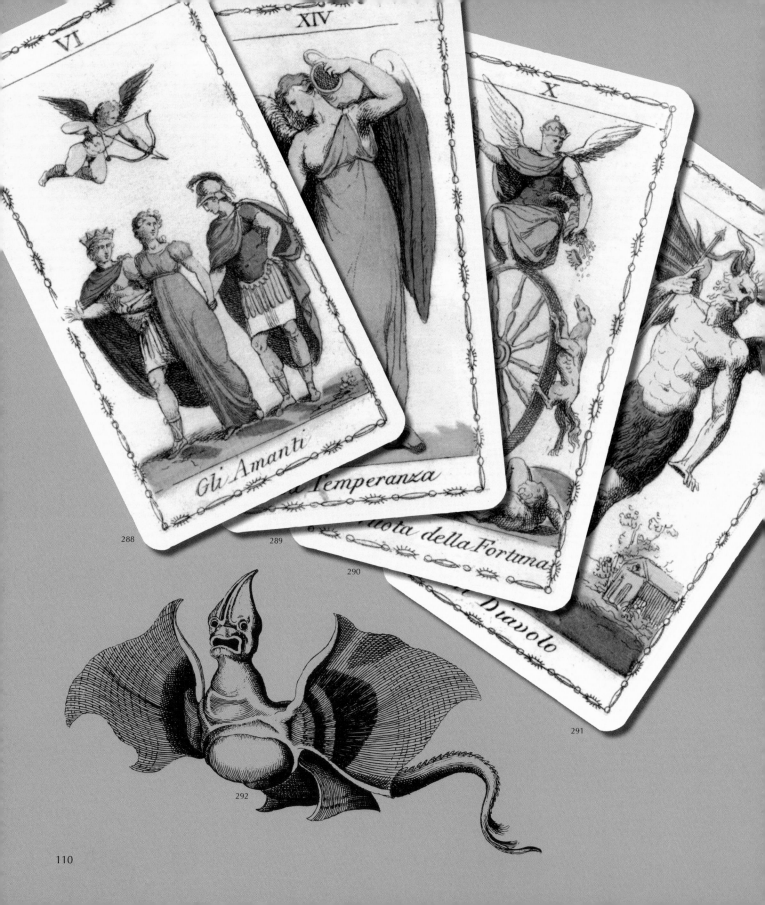

VI

Gli Amanti

XIV

la Temperanza

X

la Ruota della Fortuna

il Diavolo

288

289

290

291

292

110

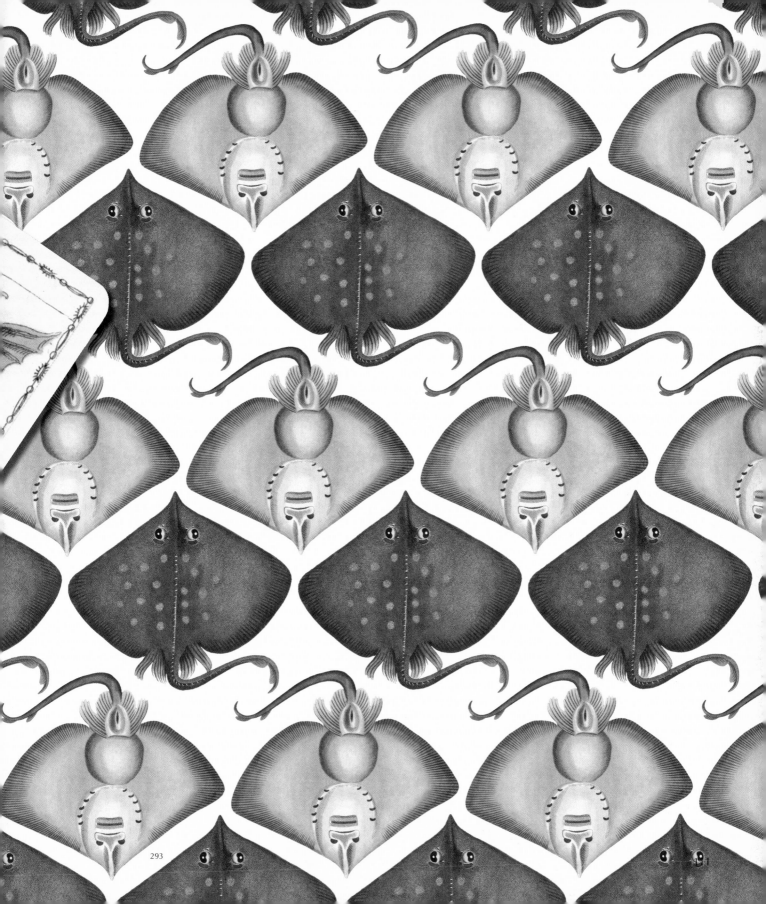

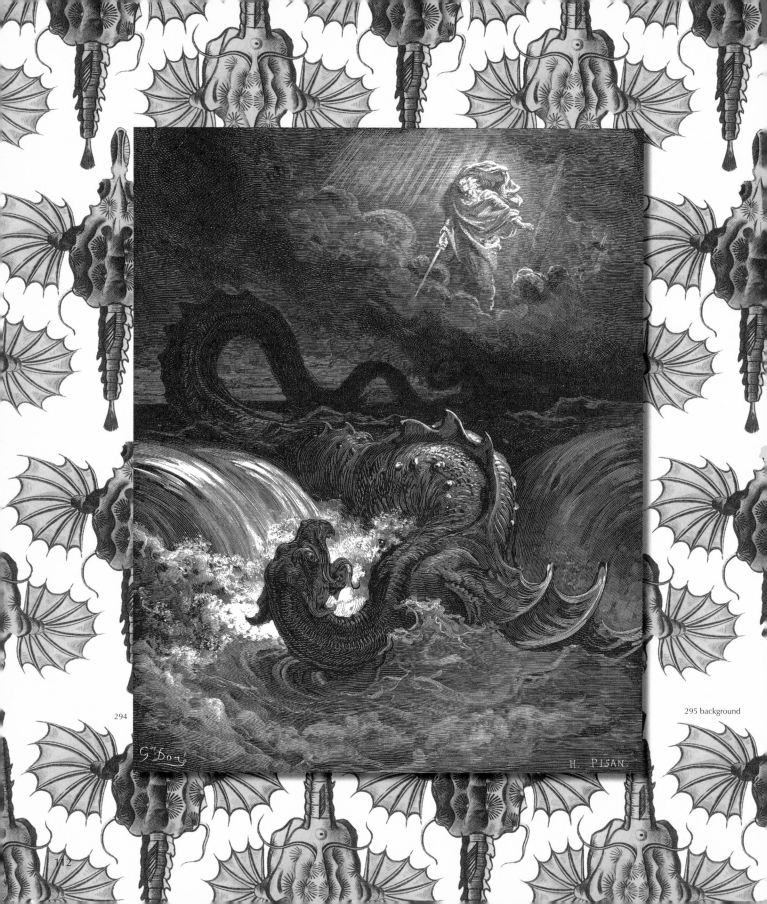

294

295 background

G. Doré

H. PISAN

296

297

298

300

301

302

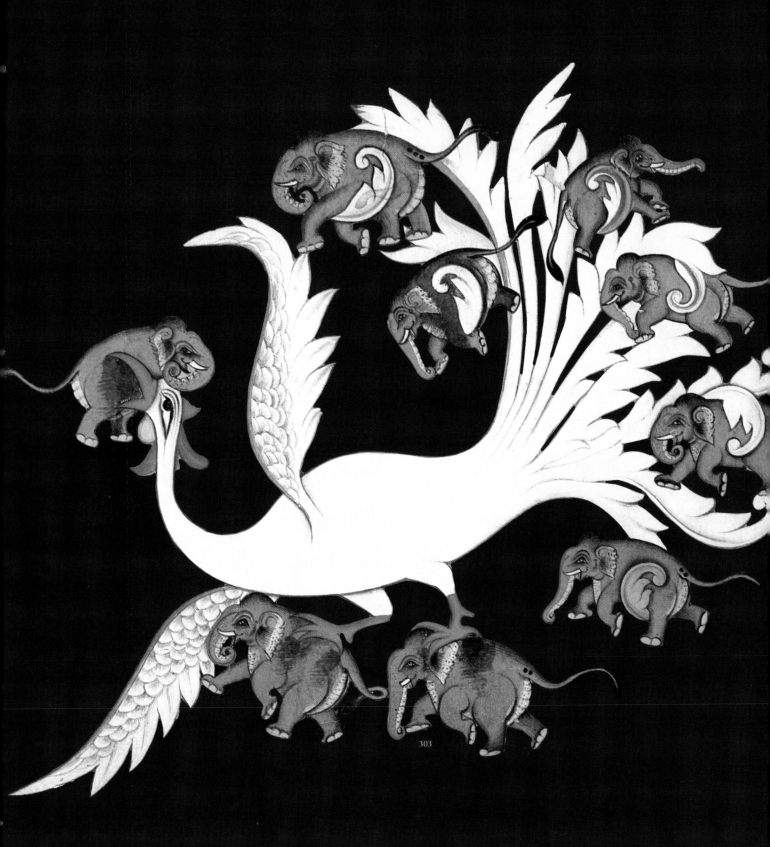

303

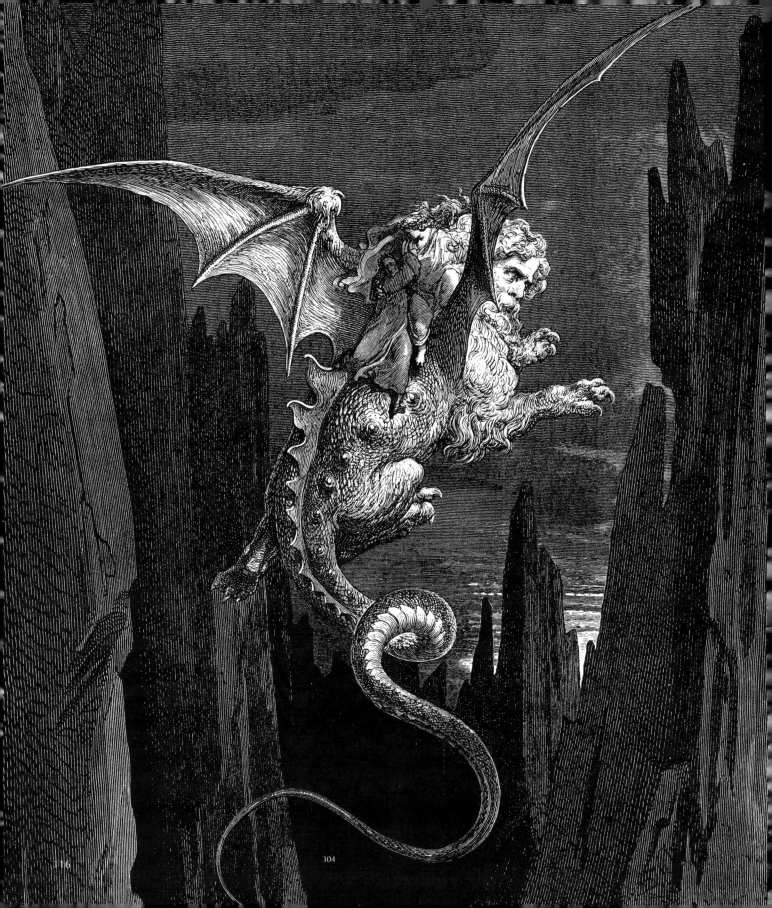

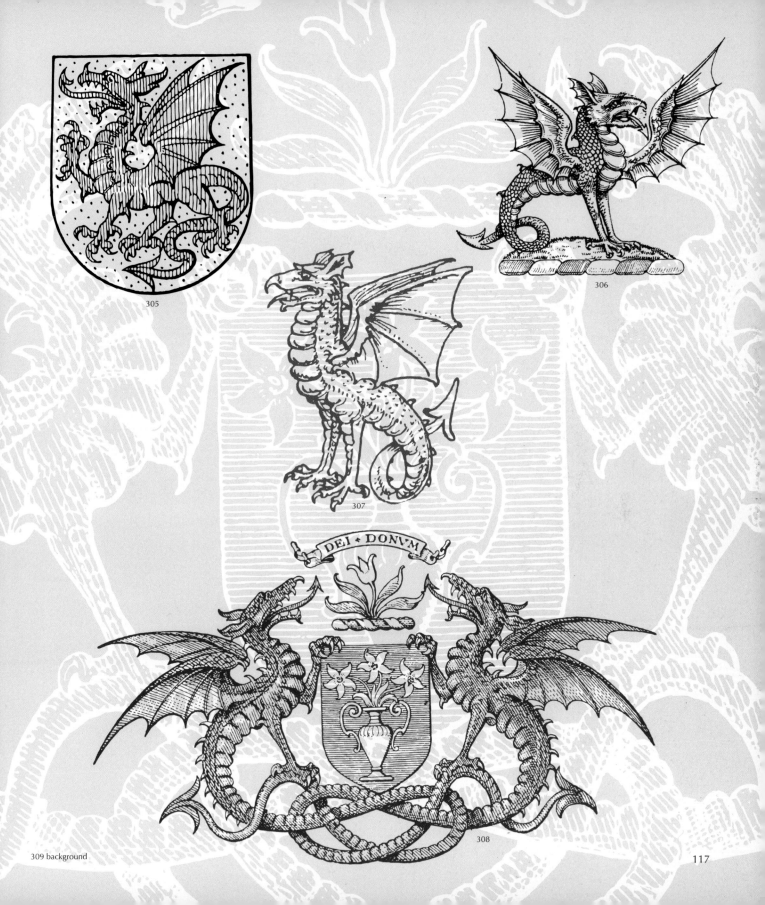

305

306

307

DEI · DONVM

308

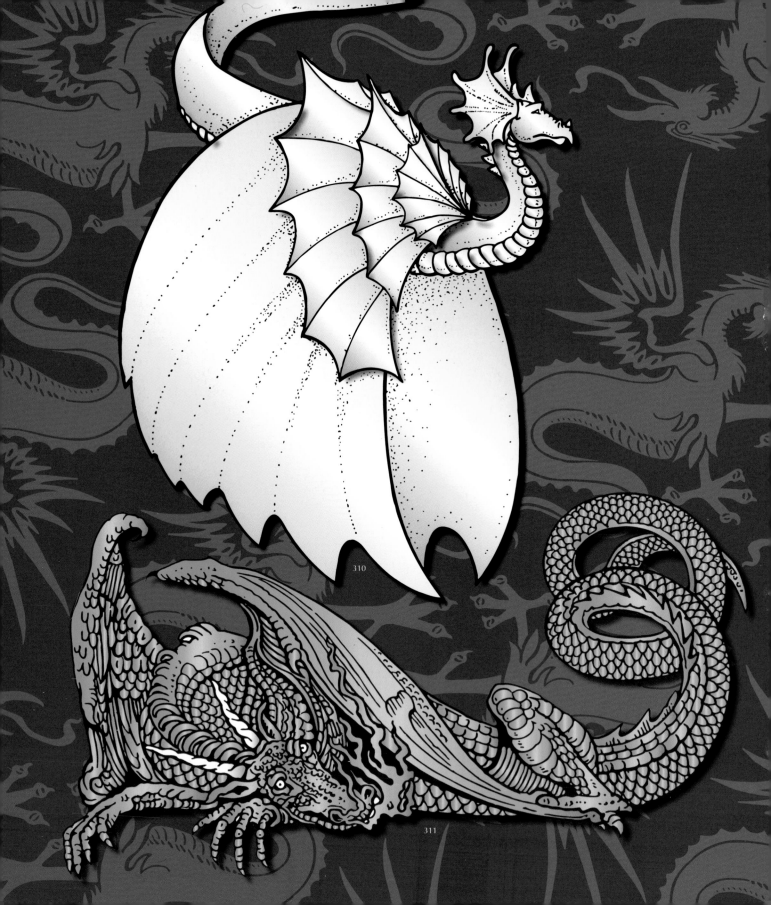

310

311

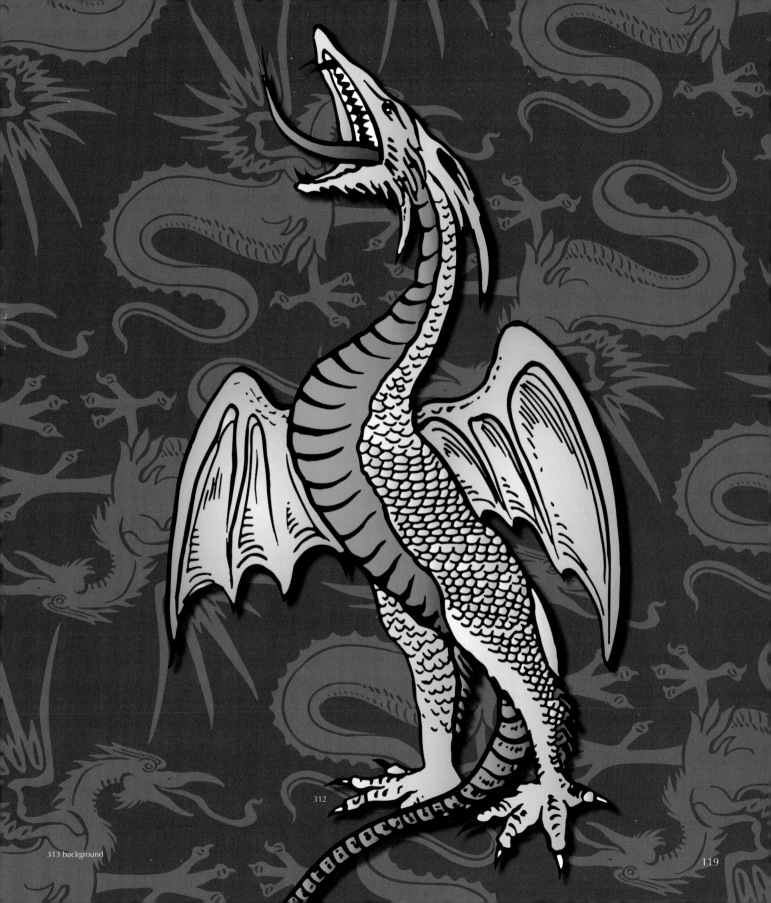

312

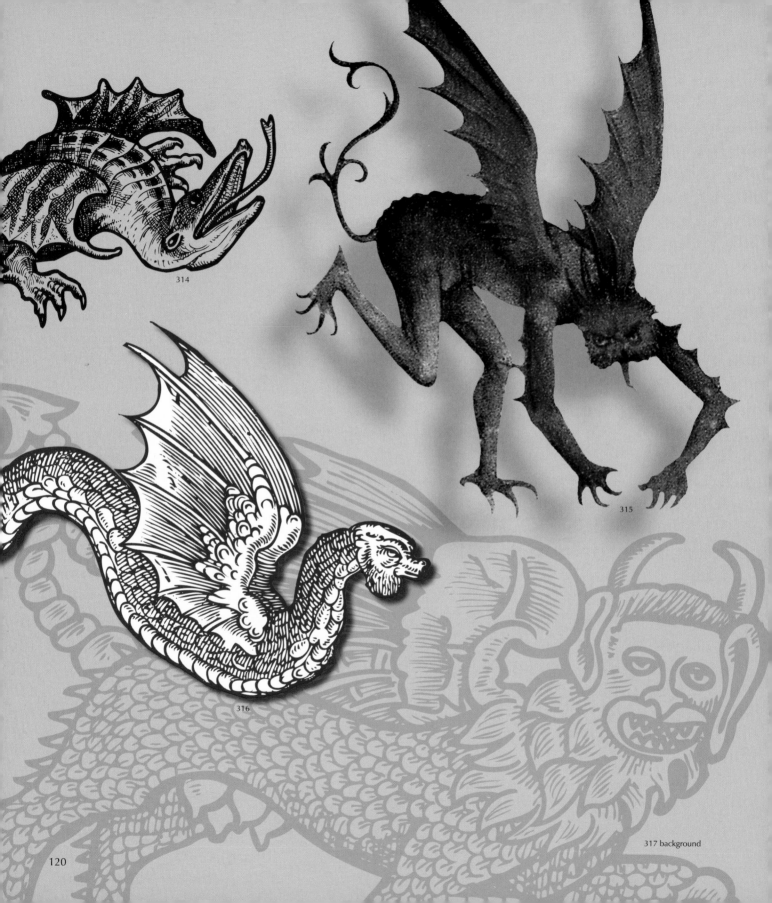

314

315

316

317 background

120

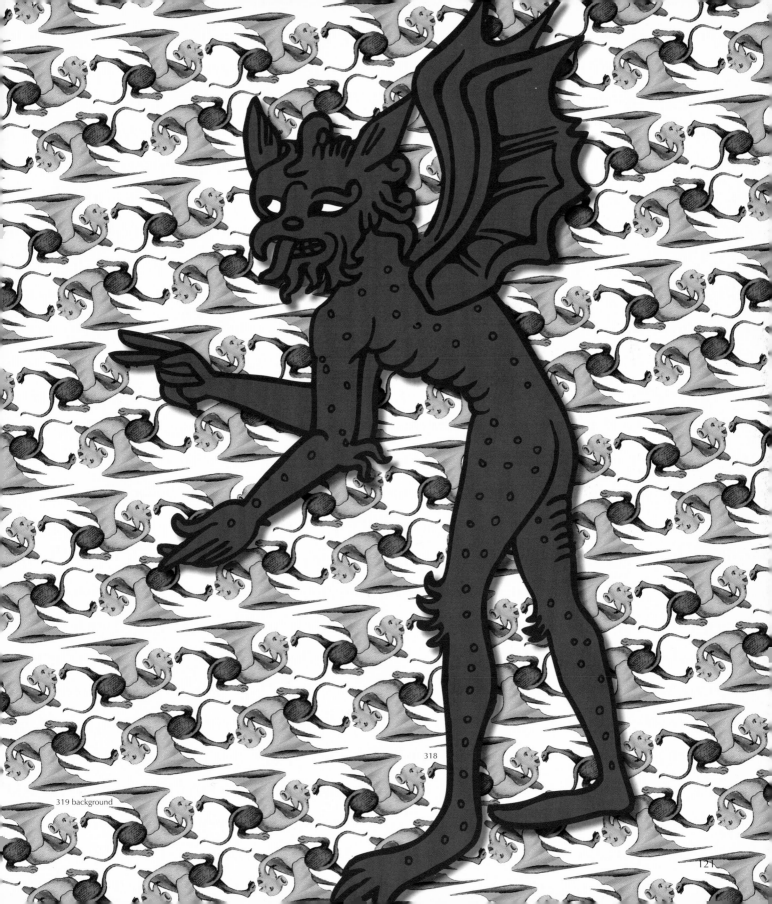

318

319 background

121

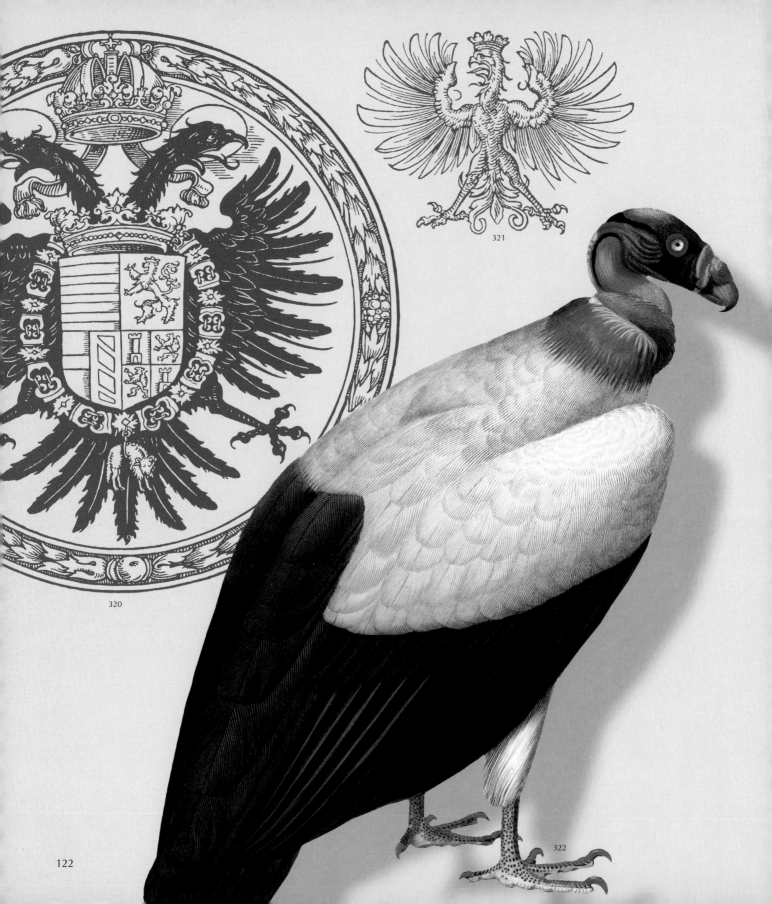

320

321

122

322

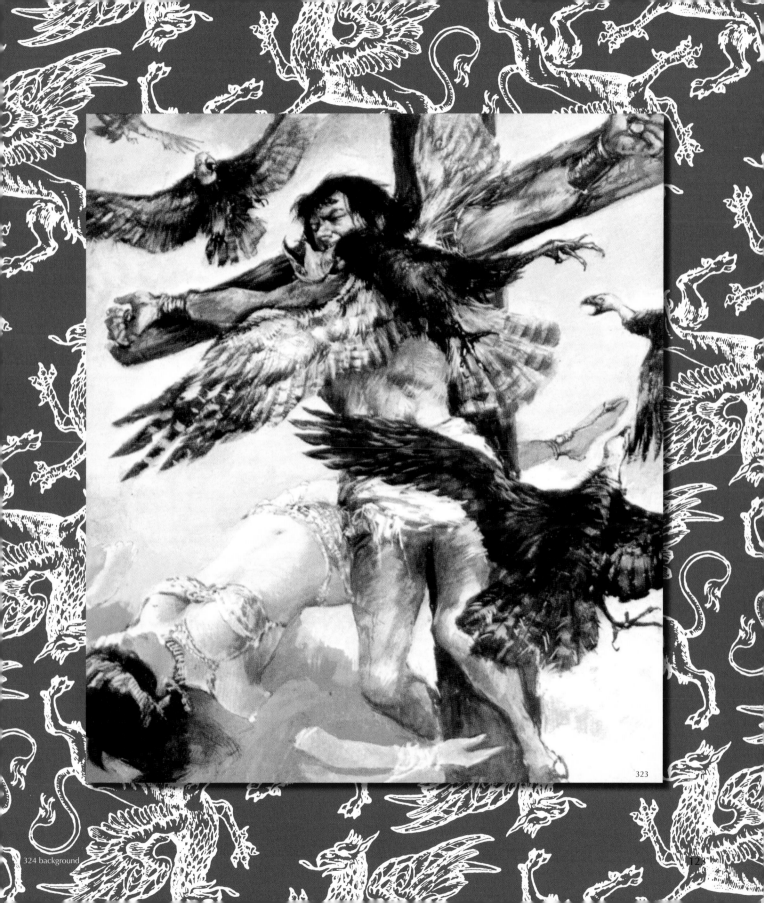

323

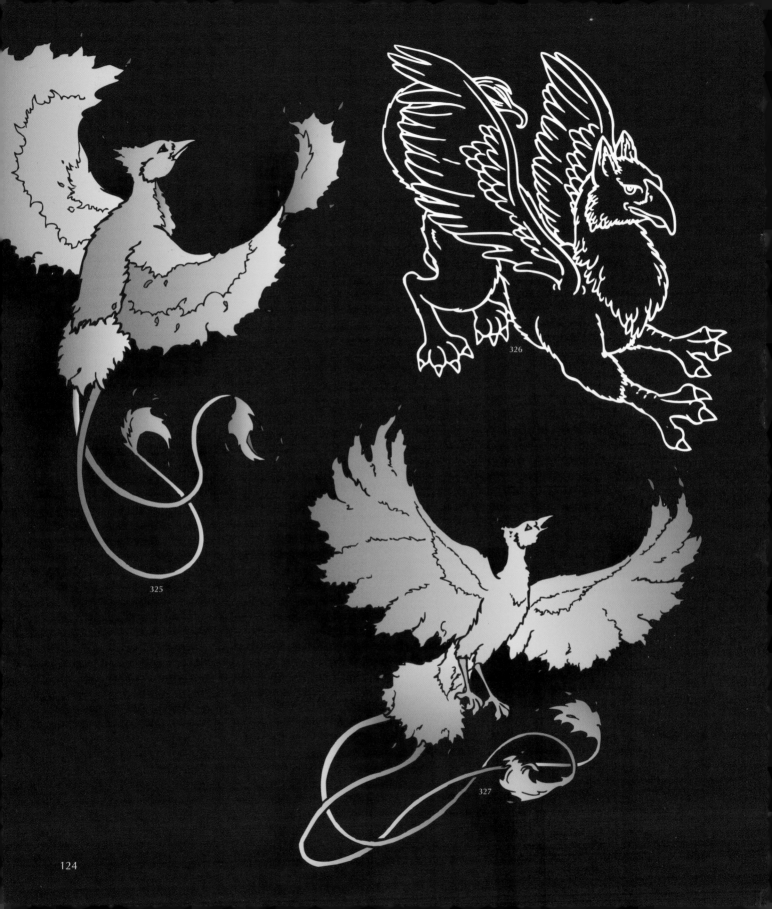

325

326

327

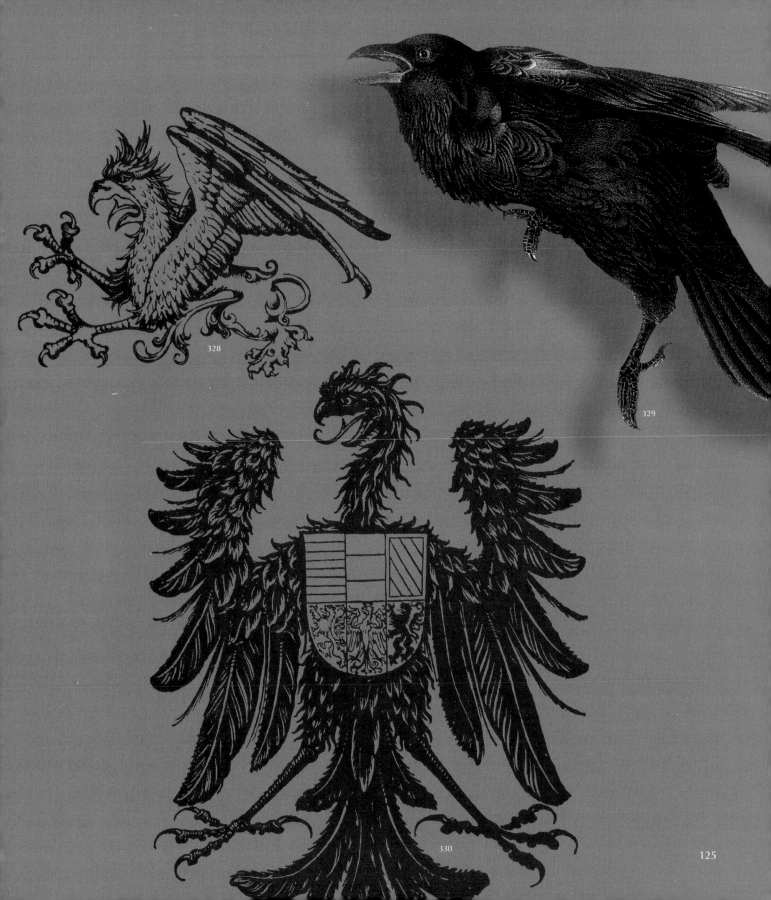

328

329

330

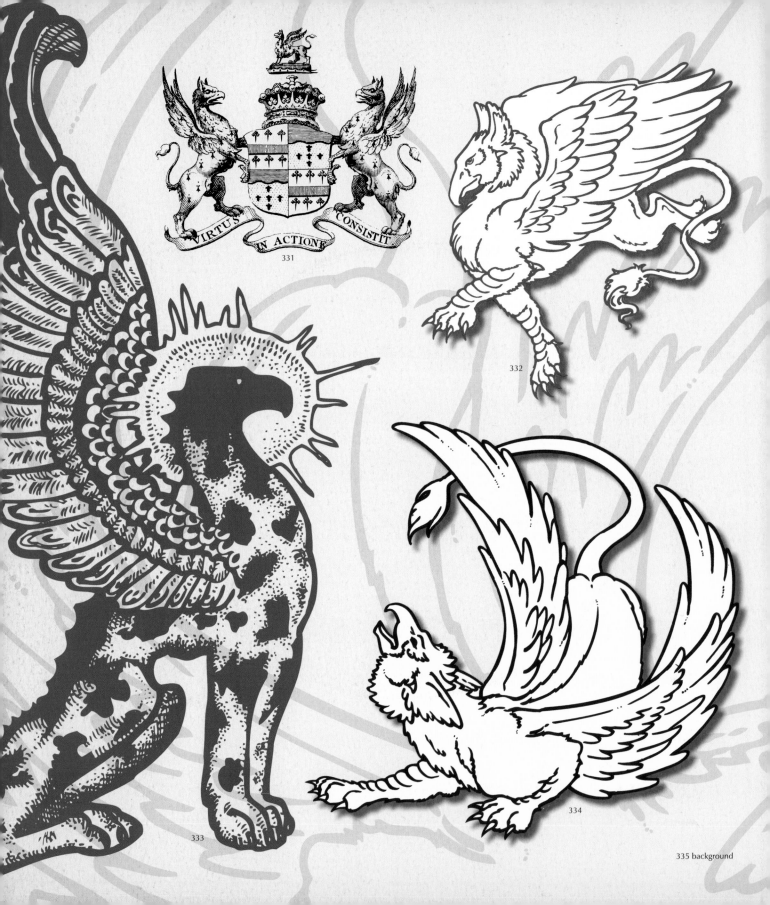

VIRTUS IN ACTIONE CONSISTIT

331

332

333

334

335 background

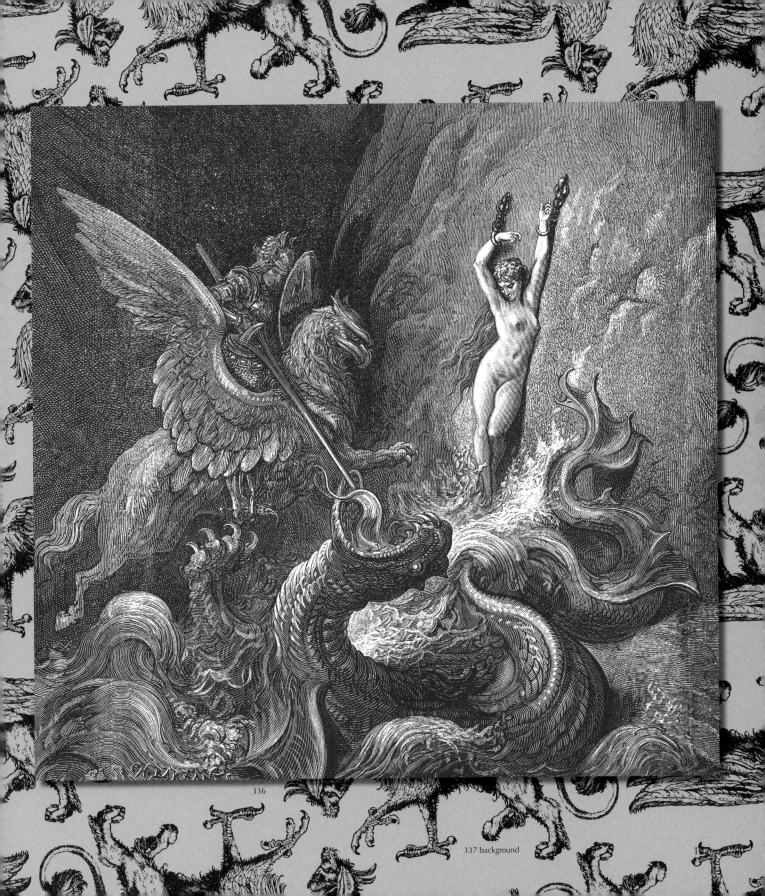

List of Images

List of Vector Images